IMAGES
*of America*

# HURRICANE IN THE
# HAMPTONS, 1938

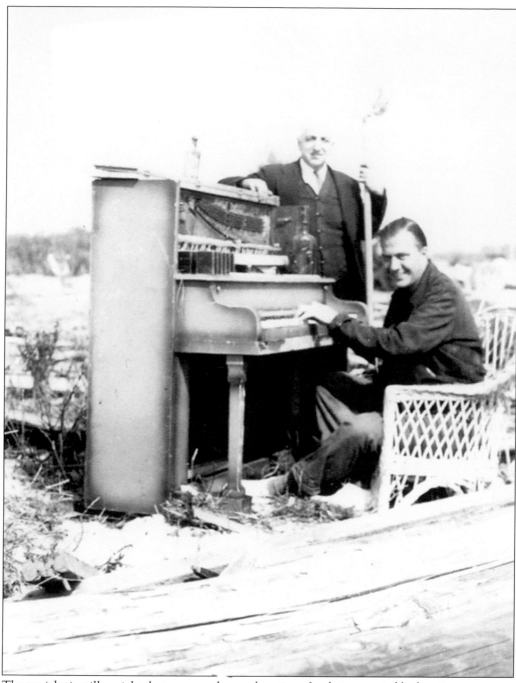

The upright is still upright, but may need a good tuning after being carried by hurricane currents from somebody's parlor to its perch on the dunes in Westhampton Beach. Mike Parlato strikes a pose as the unidentified player strikes a chord. (Courtesy Westhampton Beach Historical Society.)

*On the cover:* Please see page 61. (Courtesy Montauk Library.)

IMAGES
*of America*

# HURRICANE IN THE HAMPTONS, 1938

Mary Cummings

ARCADIA
PUBLISHING

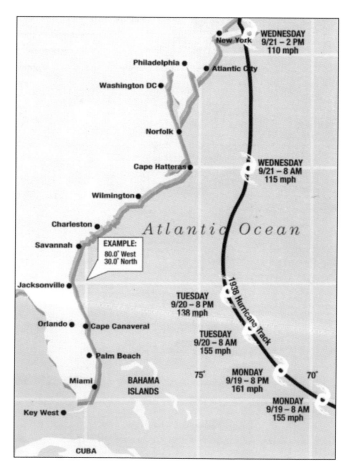

Instead of taking the expected course and veering out to sea, the 1938 hurricane rushed northward toward Long Island at record speeds. (Courtesy Eastern Long Island Coastal Conservation Alliance map.)

# CONTENTS

# ACKNOWLEDGMENTS

My thanks go to the Southampton Historical Museum and to Richard Barons for his help and encouragement; to Sheila Guidera, Barbara Lord, Scott Mitchell, Sherrill Foster, Ron Ziel, and Irl Flanagan for their photographs; to Marion Raynor Van Tassel and Virginia Kandel at the Westhampton Beach Historical Society for their help, photographs, and the use of their excellent publication, *The 1938 Hurricane As We Remember It*, published jointly with the Quogue Historical Society; to John Eilertsen at the Bridge Hampton Historical Society; Robin Strong at the Montauk Library; David Cory at the First Presbyterian Church of Sag Harbor; James Thomason at the Morris Studio; and Eric Woodward for his generous offering of selections from his extraordinary postcard collection.

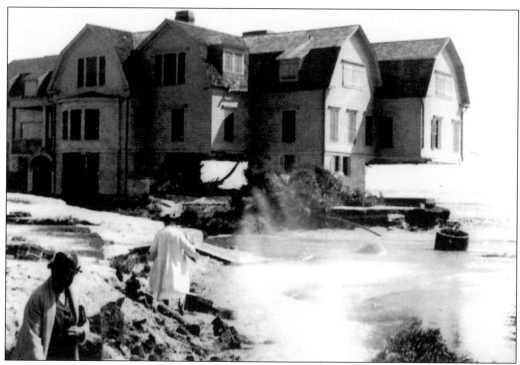

One of the many inlets opened when the Atlantic broke through to merge with bodies of water on the other side of the dunes swamped J. F. Byers's Sandymount in Southampton on its way to Lake Agawam. The badly undermined beach cottage attracted crowds of intrepid sightseers in the aftermath of the storm. (Courtesy Southampton Historical Museum.)

# INTRODUCTION

After three days of rain, the morning of Wednesday, September 21, 1938, dawned bright and fair.

In Westhampton Beach, the parents of 10-year-old Pat Driver, who had decided to take their boat out for a last day of fishing, dropped their daughter off first for a lunch party at the beachfront home of her playmate Gretchen Greene. In Southampton, 12-year-old Orson Munn and some friends thought it great sport to ride their bikes through the puddle-filled streets before drying off at Buddy McDonnell's home behind the Atlantic dunes. In Bridgehampton, Richard Hendrickson set about his farm chores after watching his wife drive off to her job in Southampton. And in Montauk, fisherman Gene McGovern headed out on his regular run to the post office to pick up his mail.

No one—not even Richard Hendrickson who had been an observer for the U.S. Cooperative Weather Service since 1930—knew what was coming. Certainly there was nothing alarming in the *New York Times*'s forecast for the day: "Rain, probably heavy today and tomorrow, cooler."

That the hurricane took everyone by surprise was not just because sophisticated forecasting technology was still far in the future. There was, after all, every reason to believe that once the storm had turned northward off the Florida coast, it would take the path characteristic of such storms and continue to curve out to sea. Nor could anyone have imagined that it would roar up the Atlantic coast at 60 miles an hour, faster than any hurricane had ever been known to travel before.

When, having covered 600 miles in only 12 hours, the storm slammed ashore at Westhampton Beach sometime before 3:00 p.m., it was accompanied by a 10-foot storm surge riding atop tides already above normal because of the autumnal equinox. The powerful surge, combined with winds of more than 100 miles an hour and pounding 30- to 50-foot waves, was enough to obliterate most shorefront property.

At the Greene house, the children's party turned nightmarish soon after lunch. The sky darkened, the winds screamed, and at 4:00 p.m., the ocean rolled over the dunes, hitting the house with such force that rooms on either end were wrenched off, leaving the children and several adults huddled in the attic of the remaining mid-section. Not until sunrise did their ordeal end, when rescuers found them where they had taken shelter in one of the few surviving houses on the barrier beach.

In Southampton, Orson Munn watched three successive waves reduce an eight-foot wall to rubble through the window of his friend's house, where the boys had been wondering what to do after lunch. The next wave was worse—a six-foot-high wall of water carrying chairs, lamps, and all manner of debris picked up along its path of destruction. Trapped, they were rescued only when three firemen, taking advantage of the brief, eerie calm that occurs when the eye of a hurricane is overhead, arrived, tied the boys together and led them through chest-deep water to safety.

In Bridgehampton, Richard Hendrickson was working in one of his chicken houses after lunch when it suddenly began to shake. He and some men working with him bolted for the farmhouse, only to watch as the roof above them was ripped off, throwing 40-pound asbestos shingles 400 feet and driving them into the ground. Helpless to prevent it, he watched scores of

his 4,000 chickens being slammed against a fence and drowned by the downpour. Meanwhile, his wife Dorothea was enduring a hair-raising drive home, skirting at least 50 downed trees, driving under the huge trunk of another and finally covering the last mile to the Bridgehampton farmhouse on foot.

In Montauk, Gene McGovern had no sooner entered the post office when the wind and tide came up so suddenly that he was unable to leave. After kicking a window, he managed to escape from the building, which had started to move and was eventually deposited some 400 feet from where it had stood.

They were the lucky ones.

A total of 52 people perished in the townships of Southampton and East Hampton and their nearby waters. Total damage to private and public property in the county was estimated at the time to have reached $24.7 million, with the Hamptons accounting for almost all of it. The largest item was the $13 million estimated value of private homes that were totally destroyed, while the cost of repairs to those damaged but left standing was put at $800,000. The cost of reconstructing the sand dunes, 90 percent of which were blown away by the wind or swept inland by the abnormal tides, was put at $1.5 million—this at a time when the nation's average annual income was roughly $1,500 and gas was 10¢ a gallon.

No amount of money could have restored the stately old elms, the pride of local villages, particularly East Hampton, where their graceful canopy had arched over Main Street for as long as anyone could remember. An *East Hampton Star* survey estimated that 42 percent of Main Street's elms had been felled.

"The sun rose this morning on the saddest sight East Hampton has ever seen," declared the *East Hampton Star*, but after lamenting the heartbreaking loss the writer concluded with this rallying cry: "Main Street will rise again!"

The defiance was typical of reactions throughout eastern Long Island, as people undertook the tasks of clearing debris and rebuilding. And yet, life in the Hamptons was in some ways forever altered. To be sure, the times were transitional for many reasons, not the least being the coming world war, which would usher in an era of world leadership and end the long Depression that had halted the pace of progress everywhere.

But the impact of the 1938 hurricane gave change a tangible presence in the Hamptons as well as a unique emotional resonance. It had been 123 years since the last major hurricane and the belief that eastern Long Island was safely out of the path of such storms had taken firm hold. The 1938 hurricane destroyed that sense of security, even as the established world order was unraveling. It is only natural that those who lived through the terrible hours from mid-day to sunset on September 21, 1938, remember them as some kind of turning point.

# One

# BATTERED BEACHFRONT

Few of the summer homes on the dunes between Westhampton and Montauk escaped the wrath of the 1938 hurricane (which predated the practice of giving storms names). Some were simply swept away; others were wrecked beyond repair. Fortunately most had been closed for the season; had the storm hit two weeks earlier, the death toll would surely have been far higher. Survivors among those who had lingered told of clinging to bits of wreckage, of heroic rescues, and miraculous escapes.

While heavy rains and fierce winds did their share of damage, the storm surge, a wall of water created by high winds that caused the ocean water to pile up, was deadly. All along the coastline, the ocean broke through the barrier beach forming new inlets and flooding the properties of sumptuous beachfront cottages and clubhouses. Rampaging seawater, weighing roughly 1,700 pounds per cubic yard and carrying tons of debris, devastated everything in its path.

In Westhampton Beach, the water, pushed by the surge, rose to a height of six feet a mile inland on Main Street and 29 people drowned. In Southampton, where cottages were reduced to matchsticks and substantial mansions were not always spared, two lives were lost. From East Hampton to Montauk, it was fishermen who paid the storm's highest toll. A month after the storm, the fatality count there stood at eight, with another seven unaccounted for—presumably claimed by the sea. Some 150 fishermen were left homeless in Montauk, and more than 80 vessels were ruined.

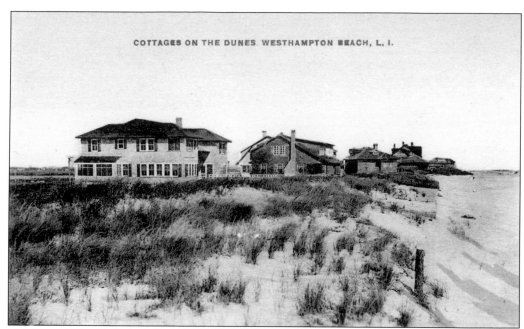

COTTAGES ON THE DUNES, WESTHAMPTON BEACH, L. I.

Of about 180 houses on the dunes in Westhampton Beach before the hurricane, only a few remained after September 21, 1938, and none were in habitable condition. While the hurricane wreaked havoc everywhere in the Hamptons, the toll was highest in the greater Westhampton area, which suffered the most direct hit under the shrieking vortex of the storm. (Courtesy Eric Woodward collection.)

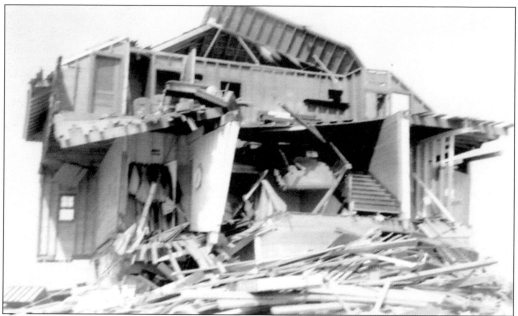

Hitting just a few hours before astronomical high tide, its deadly eye some 50 miles across and with a total width of about 500 miles, the storm hit oceanfront houses with winds of more than 100 miles per hour and waves between 30 and 50 feet high. While many were swept away, this Westhampton Beach house simply disintegrated on the spot. (Courtesy Scott Mitchell.)

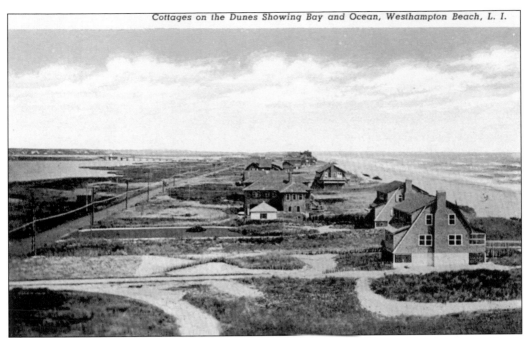

The narrow barrier beach separating the Atlantic from Moriches Bay in Westhampton Beach presented no obstacles to the storm surge once the sea had crashed through the protective dunes and trapped many people when their homes were swept away. The strip's vulnerability is evident in this pre-hurricane image showing a clear field for the churning debris-filled waters, which raised waterways and canals to unprecedented heights and inundated Main Street shops. (Courtesy Eric Woodward collection.)

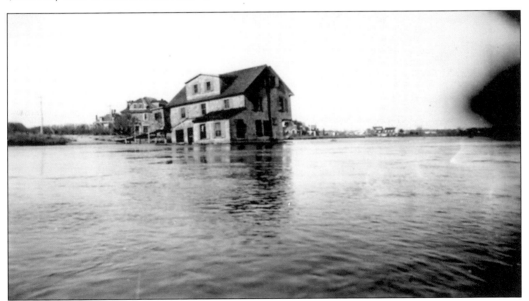

These houses on the bay that separates the barrier beach from the mainland in Westhampton Beach appear to be floating on the swollen waters in the hurricane's immediate aftermath. On the day after the hurricane, Westhampton resident Lee Davis remembered that "the choking smell of the bay bottom was everywhere." (Courtesy Scott Mitchell.)

Debris in front of the Lynch cottage may well be the remains of the nearby West Bay Beach Pavilion (later the Swordfish Club), which was totally destroyed. Although by 2:00 p.m. on September 21, members of the Westhampton Beach police department were banging on the doors of homes like this one on the barrier beach, earlier in the day swimmers had been seen in the ocean, as writer Lee Davis later recalled. What he remembered most vividly, however, once the storm had reached its full fury, was "the voice of the storm," something others have

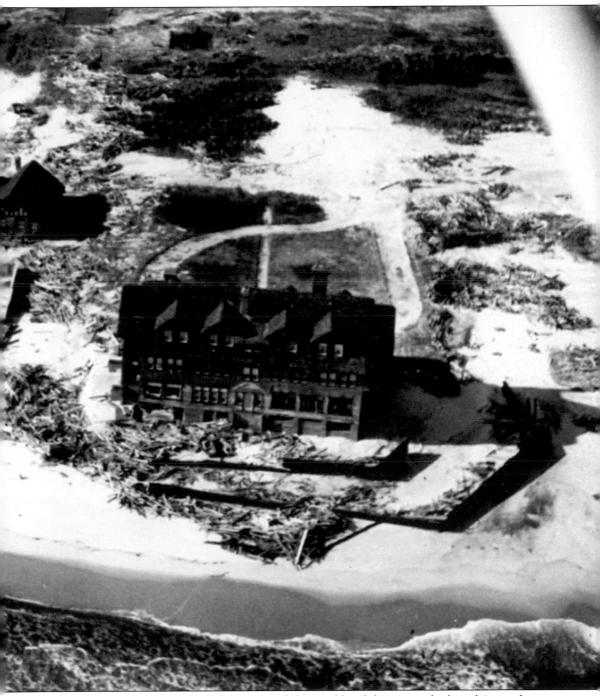

mentioned. Beyond the shriek of the wind and the rumble of the ocean, he heard "something unique and pervasive, a pedal tone, the sort of almost subliminal note that is so intense it is felt rather than heard." Orson Munn of Southampton spoke of an initial moan that intensified by stages to a howl and then to a shriek—a noise "so intense you can't absorb it." Hence "the silence of a hurricane" that some survivors have mentioned. (Courtesy George Haddad, Ron Ziel collection.)

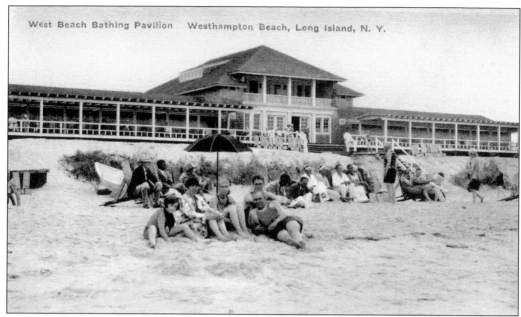

West Beach Bathing Pavilion    Westhampton Beach, Long Island, N. Y.

People had been complaining about the weather all summer in 1938. It had been hot, sultry, humid, and wet—not the ideal beach conditions these sun worshippers appear to be enjoying at Westhampton Beach's West Bay Pavilion in happier times. A few hardy souls were actually lured to the beach on September 21, although the greenish hue to the sky, so frequently mentioned by hurricane survivors, may have warned others away. (Courtesy Eric Woodward collection.)

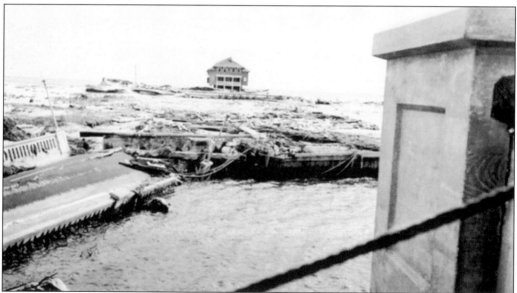

The hurricane's ferocious winds and pounding waves ripped off the south end of the West Bay Bridge in Westhampton Beach, rendering it useless. Mangled lampposts, railings tangled in seaweed, and debris from the ruined bathing pavilion were all heaped together in a scene of terrible devastation at the end of the day. Of 179 houses between Moriches Inlet and the Quogue line, only a few remained after the hurricane, and those were left in uninhabitable condition. (Photograph by Richard M. Johnson.)

14

The view from the ruined West Bay Bridge resembled a moonscape after the storm. Beach cottages that had dotted the dunes were gone, swept away piece-by-piece, while their furnishings were scattered, sometimes turning up in the most unlikely locations far from their point of departure. Furniture, wood planks, and even boats were strewn all over the Westhampton golf course. (Photograph by Richard M. Johnson.)

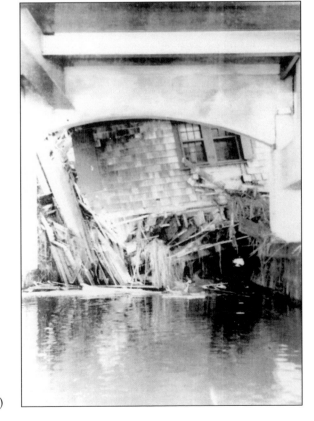

Edna Raynor's memories of the hurricane documented in the Quogue and Westhampton Beach Historical Societies' publication tell of terrifying hours spent in the bridge tender's house atop the Rogers Bridge at the end of Beach Lane. Waiting out the storm there, she and her husband watched as the lower part of one house "went under the bridge and got stuck" while the roof "went flying over." (Courtesy Westhampton Beach Historical Society.)

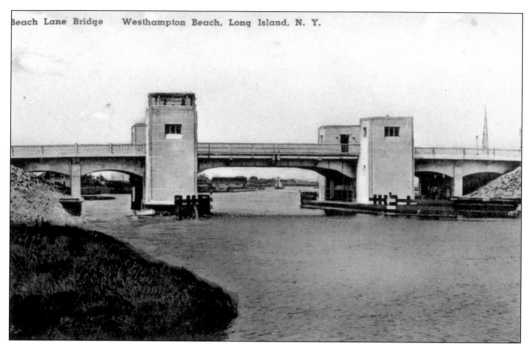

The Rogers Bridge was identified in this pre-hurricane postcard as the Beach Lane Bridge. It owed its more familiar name to the popular beach club and fishing station owned by Demarest Rogers to which the bridge led. Elizabeth Raynor Barnish recalled that her father had been on Dune Road when the storm struck. He had gotten as far as Rogers Bridge and then "left his car and ran for his life." (Courtesy Scott Mitchell.)

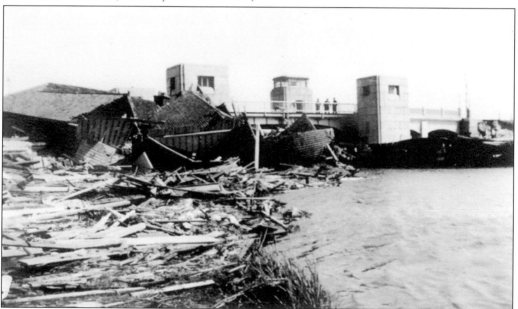

The Rogers Beach Club, or Rogers Pavilion, was badly damaged in the hurricane, leaving mounds of debris at the water's edge. The rogue house, which belonged to the Sweeney family, was eventually dislodged from under the bridge, and beachgoers still flock to the beach at the spot, although it is no longer a Rogers family enterprise. (Courtesy Scott Mitchell.)

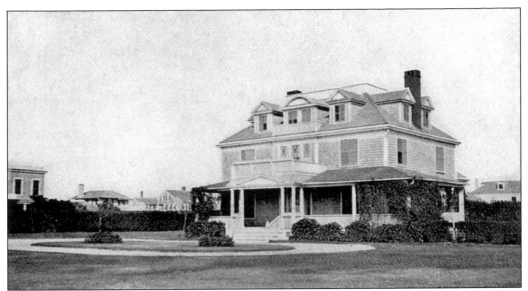

Dr. Harry Beekman's summer cottage on Beach Lane in Westhampton Beach looked solid enough to withstand just about anything. It did, in fact, survive the hurricane, although Beach Lane was no place to be on September 21. It was the route Senta Larson and her brother took home from school that day, and she later recalled (in the Westhampton Beach and Quogue Historical Societies' publication *The 1938 Hurricane As We Remember It*) that had they left school 15 or 20 minutes later, they "would have surely died going down Beach Lane." (Courtesy Eric Woodward collection.)

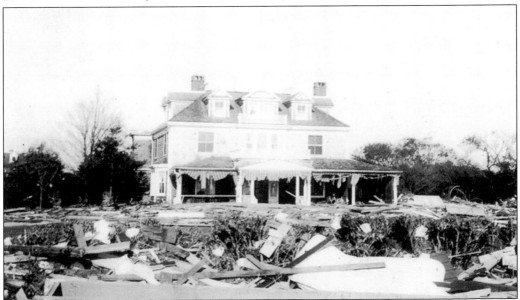

The Beekman house still stood after the storm, but not quite as proudly. Shredded awnings and scattered debris attest to the violence of the assault it withstood. Down the road, where the Larson family occupied chauffeurs's quarters on a Beach Lane estate, the children watched the water rise, carrying planks and even huge sections of buildings. When a rowboat hit the side of the house, they made contingency plans (mercifully unnecessary) to climb out the second-story window and row themselves to safety. (Courtesy Marion Van Tassel.)

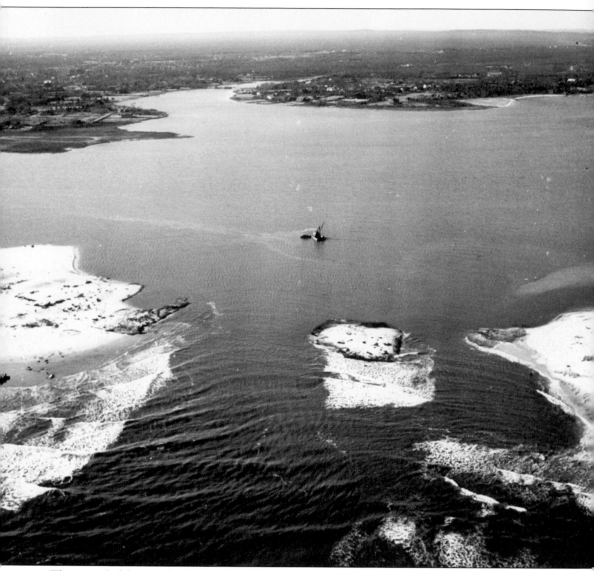

The mingled bay and ocean at Westhampton Beach reached unprecedented heights. Water washed into Moniebogue Bay at the south edge of the village (top), flooded Main Street, and kept on going, reaching Montauk highway at Cook's Pond where it left a large yacht high and dry after receding. Beach Lane and Library Avenue were jammed with wreckage from the disintegrated dune houses, and stores on Main Street were inundated. Mike Parlato, whose home was at the water's edge, was driving toward the West Bay Bridge when he saw the wall of water so many survivors have described. Turning around, he tried desperately to outrun the flood. Reaching Main Street at the same time as the water, he abandoned his truck and swam. Debris was everywhere, and the current was raging. But somehow he made it to safety, although not before the current had bashed his body up against the Grimshaw Building, later the Main Street apartments. (Courtesy George Haddad, Ron Ziel collection.)

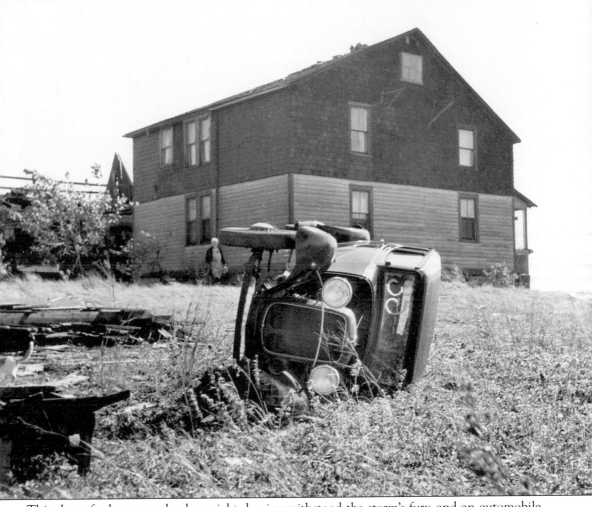

This shot of a house resolutely upright, having withstood the storm's fury, and an automobile gently tipped on its side has a preternatural calm. Never mind that the house may well be gutted, filled with mud and even a dead fish or two. And never mind that the car may have been swept up in some swift-moving current and dumped here far from its home garage. George W. Burghard, who wrote one of the most detailed accounts of the hurricane, which appears in *The 1938 Hurricane As We Remember It: Volume II*, writes of searching the landscape for many days after the hurricane and finding objects that belonged to him and his wife Mabel scattered far and wide: the roof and attic of his house, behind the first hole of the Westhampton golf course, three miles away; a radio pole on the first green; his suit vest, 20 feet up in a tree; his wife's riding boots, a half-mile from each other; and one of his slippers, a mile inland near a Coast Guard lifeboat. Two weeks later, his briefcase, papers, and checkbooks were found under 10 feet of wreckage on the golf course. On the beach where his house once stood, he found part of a loudspeaker, the kitchen sink, and a card table with only one leg broken. (Courtesy George Haddad, Ron Ziel collection.)

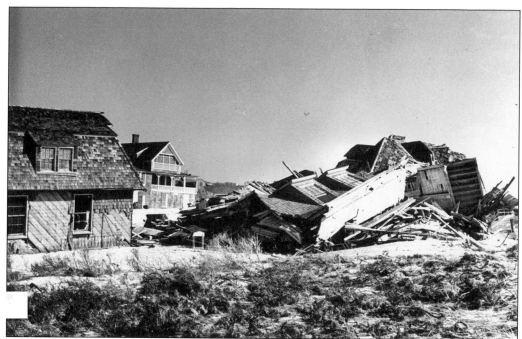

The ocean broke through the dunes at several places in Quogue, wreaking havoc on beach houses like these. The Quantuck Inlet, created at the Westhampton Beach–Quogue line, is said to have been 400 feet wide and 20 feet deep at its greatest breadth and depth. The water surging through washed north nearly a mile, tearing out the causeway between Quogue and Quiogue. A section of the Long Island Rail Road tracks was washed out, the Quantuck Beach Club was carried away, the surf club was badly damaged and the field club lost half its golf course when Ogden Pond overflowed. Two young men from Quogue—Thomas Fay Jr. and Charles Lucas Jr.—tragically lost their lives on a rescue mission. A Dune Road homeowner offered them a large reward to go to the beach at the height of the hurricane and rescue two dogs stranded in the house. Their bodies were found six days later on the Hampton Bays shore. (Courtesy George Haddad, Ron Ziel collection.)

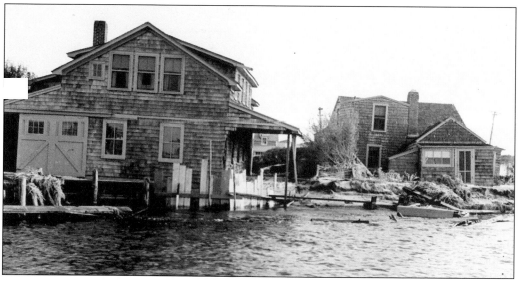

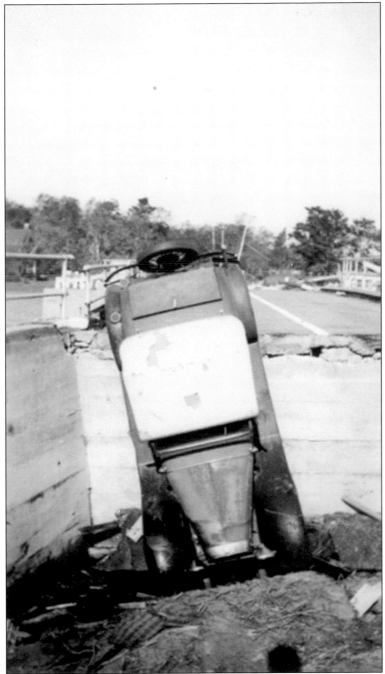

This car was caught when the causeway at Quantuck linking Quogue to Quiogue washed out. In her reminiscence for the Quogue and Westhampton Beach Historical Societies, Elizabeth Carman Rogers recalled that it was her first wedding anniversary on September 21 and she had been driving back to her home on Montauk Highway in Westhampton after visiting her parents when the already bad weather took a sudden turn for the worse. Looking back in her rearview mirror after crossing the causeway, she saw "a horrible sight." The bridge she had just crossed had given way. The driver of the next car was not so lucky. (Courtesy Scott Mitchell.)

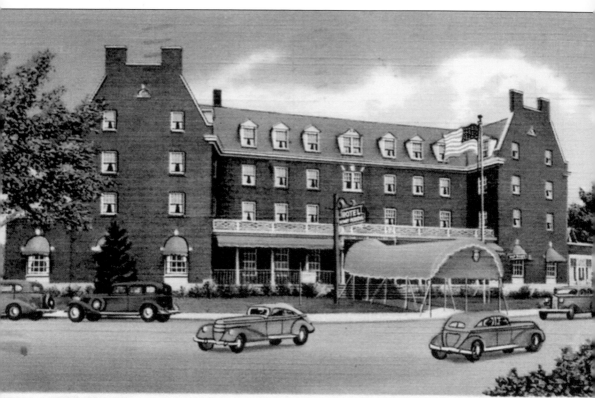

**HOTEL HENRY PERKINS** — RIVERHEAD, LONG ISLAND, N. Y., A METROPOLITAN HOTEL IN A COUNTRY SETTING

The swank Henry Perkins Hotel, on high ground in Riverhead, took in hundreds of people who had taken flight from the storm and had nowhere to go. The management put out free food and drink, while at an emergency communication booth set up across the street from the hotel, police were receiving and transmitting calls for rescues and compiling reports on the missing and the known drowned. Patricia Driver's parents, frantic with worry over the fate of their daughter who had been invited to a children's lunch party at a friend's beach house, and unable to get through to the beach or even to return to their own home, were given the last room available at the hotel. Mr. Driver later recalled the eerie scene that evening in the hotel lobby, which was lit only by candles and flashlights. As the dazed and distraught storm refugees straggled in, the hotel's regular clientele sat calmly reading their newspapers. Although the headline screamed "Hitler Marches into Sudetenland!" it meant little to him, he recalled. "We were so frightened and worried about or daughter, Patricia." Their happy reunion took place the next day. (Courtesy Southampton Historical Museum.)

*The Hampton Chronicle*
*Friday, September 30, 1938*

# LIST KNOWN DEAD

## Westhampton Beach

Bailey, Beulah. Maid at Surf and Dune Club.

Bragaw, Mrs. Katherine, aged 63 of 732 Berkeley Ave., Orange, N.J.

Bragaw, Miss Carolyn, aged 18, daugher of the above.

Brown, Mrs. Peggy, aged 21, wife of Peter C. Brown, of 50 Montgomery Place, Brooklyn.

Clelland, Miss Agnes, aged 67, maid in household of Archibald MacFarlane.

Dalin, Carl E., aged 67, of 44 Hawthorne Ave., Williston Park, L.I.

Dalin, Selma M., aged 64, wife of Carl E. Dalin.

Douglass, Payson Stone, aged 53, of Llewellyn Park, West Orange, N.J.

Flagge, Mrs. Marianna Bishop, aged 76, of New Rochelle, N.Y.

Foley, Mrs. Leo, aged 50, of 426 Clermont St., Brooklyn.

Jarvis, Mrs. William, aged 63, of Westhampton Beach.

Jenkins, Lena, colored, aged 44, of Charleston, West Virginia. Employed at Gunning Point House.

King, Mrs. John L., aged 60, of Westhampton Beach.

Lea, Mrs. Edward P., aged 52, of South Orange, N.J.

Lewis, Warren G., aged 55, proprietor Surf and Dune Club.

Lewis, Frances, aged 63, wife of Warren G. Lewis.

Melvin, Robert, colored, aged 34, bartender at Surf and Dune Club.

Mudford, Mrs. Katherine, aged 65, of 840 Union St., Brooklyn. Hostess at Surf and Dune Club.

O'Brien, Mrs. J.F., aged 30, of 381 Central Park West, New York City.

Pinks, Mrs. James L., aged 55, of 969 Park Avenue, New York City.

Schlater, Mrs. Charles W., aged 51, of Washington, D.C.

Seeley, Anna, aged 37, colored, of 35 Pierrepont St., Brooklyn.

Williams, Mrs. Alverta Rivers, aged 44, of Quiogue.

## Quogue

Fay, Thomas, Jr., aged 21, of Quogue.

Lucas, Charles, Jr., aged 20, of Quogue.

This is a list of those who died. (Courtesy Westhampton Beach Historical Society.)

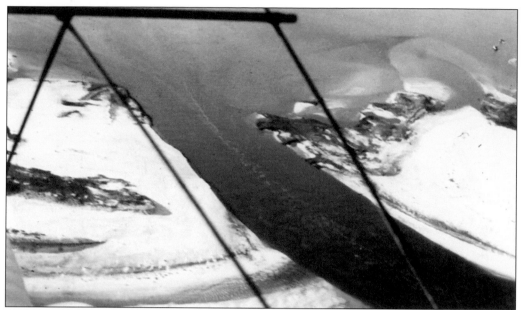

In the Westhampton area, where the storm struck with the greatest force, the ocean broke through to every body of water contiguous to the dunes. This aerial view taken soon after the hurricane hit shows the newly formed inlet on the site of the former Hampton Bays Coast Guard Station, which was destroyed. The Shinnecock Inlet and the Shinnecock Canal, later dredged and lined for the benefit of boat traffic, remain as permanent reminders of the 1938 disaster. (Courtesy Southampton Historical Museum, Barbara Lord.)

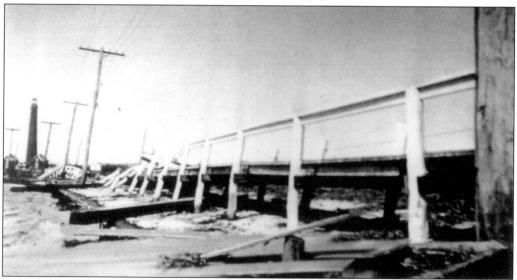

The wind and waves did not spare the area around the Ponquogue Lighthouse (also known as the Shinnecock Lighthouse, far left) as this post-hurricane view reveals. For decades after its erection in 1858, it was a relied-upon beacon at the halfway point between the Montauk and Fire Island lighthouses. Taken out of service in 1931 and replaced by a purely functional tower with a beam that flashed 14 miles out to sea, the lighthouse survived the 1938 hurricane only to be demolished in 1948, despite preservationists' efforts to save it. (Courtesy Southampton Historical Museum.)

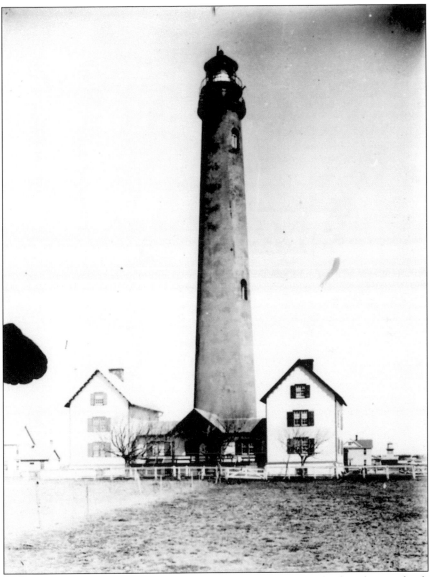

The Shinnecock Coast Guard station and the electric beacon on the beach were both washed away by the hurricane of 1938. After the storm, the government authorized a new station and beacon to be built on the mainland. In the meantime, the light on the beach was replaced. As Helen Wettereau relates in her book *Good Ground Remembered*, in early 1940 the New York district office of the Coast Guard made a survey of the condition of the lighthouse and reported that it was "in a dangerous condition" and advised demolition. A conflicting view was expressed by the Alphons Custodis Chimney Construction Company, which recommended repairs and improvements that would make it structurally safe and stable. When the campaign to save the lighthouse failed to sway authorities, the Coast Guard included in its budget funds for the construction of a new light and the removal of the old structure. In December 1948, the Vim Demolition and Salvage Company began demolition work. It took a crew of seven men working for two weeks to cut through the thick brick walls. On December 23, 1948, the men soaked the old pine timbers, ignited them and the lighthouse crashed to the ground. (Courtesy Southampton Historical Museum.)

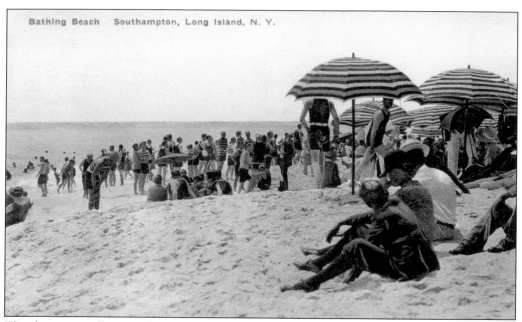

Bathing Beach    Southampton, Long Island, N. Y.

Thanks in no small part to their wide, unspoiled beaches, the villages and hamlets of Southampton town were ranked among the most fashionable resorts on the East Coast at the beginning of the 20th century, a distinction they continued to hold in 1927, when this postcard was sent, and still enjoy to this day. At first, the summer visitors lodged in boardinghouses, but before long they were building their own sprawling summer cottages, many of them on the dunes. (Courtesy Eric Woodward collection.)

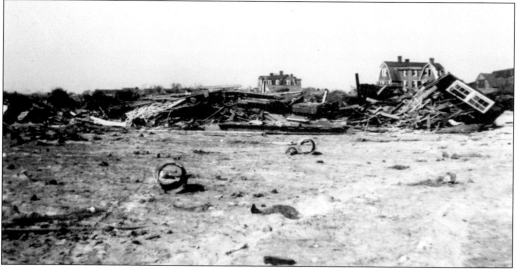

By sunset on September 21, 1938, the beachfront in Southampton presented a scene of unbelievable wreckage and desolation. Whole houses had been ripped from their foundations and cast adrift. Others had been knocked askew or pummeled to pieces, their furnishings flung over the beach. Occasionally a cake about to be cut or a shelf lined with glassware remained miraculously undisturbed in a structure that had been sliced in half or left roofless. But it was a rare house from among those lining the dunes in Southampton that survived intact. (Courtesy Southampton Historical Museum, Sheila Guidera.)

Stretching from the leafy streets of Southampton village southward almost to the Atlantic is Lake Agawam. From the resort's earliest days, lots along the lake's shores have been highly prized, rivaling, if not trumping oceanfront properties. Alas, the area around Lake Agawam was also among the village's most vulnerable neighborhoods in 1938 when the storm surge pushed over the dunes into the lake, wreaking havoc not only on the sumptuous cottages ringing the lake and dotting the dunes but on the fashionable St. Andrew's Dune Church and the elite clubs—the Bathing Corporation and the Meadow Club—that were the centers of "summer colony" social life. The photograph above, taken by Richard M. Johnson on September 21, shows lake and ocean waters flooding the South Main Street approach to the beach. The distinctive peaks of St. Andrew's Dune Church are visible in the distance. Below, in a photograph taken a day or so later, the view is of the damaged east end of the Bathing Corporation next door to the church, showing parked cars caught in the flood. (Courtesy Southampton Historical Museum.)

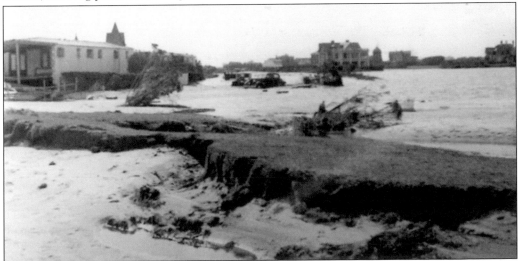

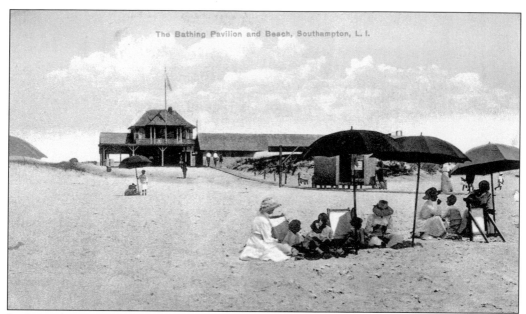

The Bathing Pavilion and Beach, Southampton, L. I.

In the early 1900s, a bathing pavilion on the beach at the south end of Lake Agawam welcomed the public with bathhouses and a small cafeteria. A 1908 brochure included it in its list of Southampton village attractions and noted that it boasted "two able surfmen on duty during the bathing season and 230 separate bathing houses." In 1923, the Bathing Corporation of Southampton acquired the property with an eye to creating a private club whose members would be drawn almost exclusively from the summer community. Here patrons of the original bathing pavilion enjoy a day at the beach. (Courtesy Eric Woodward collection.)

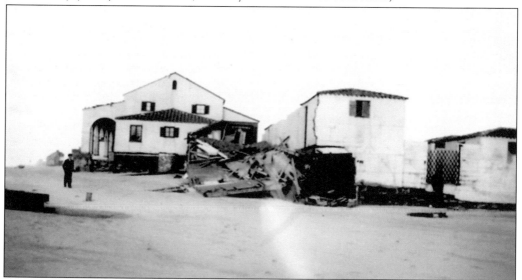

In 1927, the Bathing Corporation acquired the beachfront land separating it from St. Andrew's Dune Church to the west and by 1930 work had been completed on the familiar Spanish-style Bathing Corporation building and adjacent swimming pool. The 1938 hurricane reduced the sections of the old pavilion that were still in use by the Bathing Corporation to rubble, some of it seen here, stacked against the club's newer buildings, which also suffered considerable damage. (Courtesy Southampton Historical Museum.)

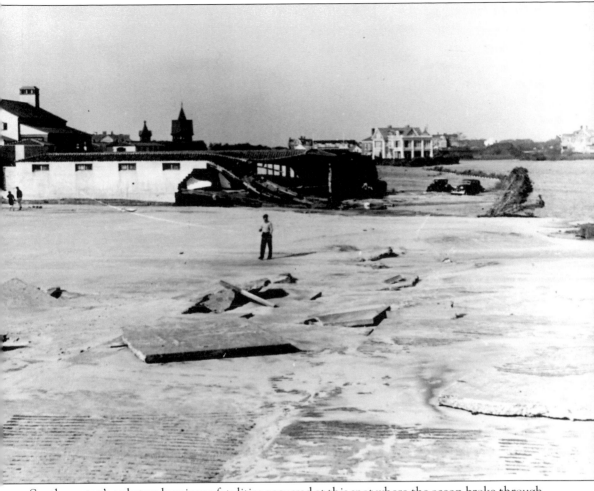

Southampton's only two hurricane fatalities occurred at this spot where the ocean broke through the dunes by the Bathing Corporation, sweeping everything in its path into Lake Agawam. Sisters Della Johnson and Florence Hunter, who were from the Shinnecock Indian reservation at the outskirts of the village, had been on their way to visit Hunter's daughter in Southampton Hospital, along with a third sister, Mary Davis, and the three women's mother, Mrs. Everett Lee. Unaware of the magnitude of the approaching storm, they were apparently drawn toward the ocean for some sightseeing when toppling trees blocked their route back to town. They sought refuge in the Bathing Corporation building where several employees were also waiting out the storm. When the waves began pounding the doors, it was decided to abandon the building and head for the DeWitt cottage (visible in the distance with pillared porch) but they had scarcely set out when the sea broke through the dunes in a series of huge waves. Hunter is thought to have drowned in the road. The others were washed against a privet hedge, which apparently saved the lives of all but Johnson. When another huge wave swept her away from the group, lifeguard Dan Ferry went to her assistance, but yet another wave carried her out of reach and swept him into the lake where he battled for an hour and a half before finally reaching shore. (Courtesy Southampton Historical Museum.)

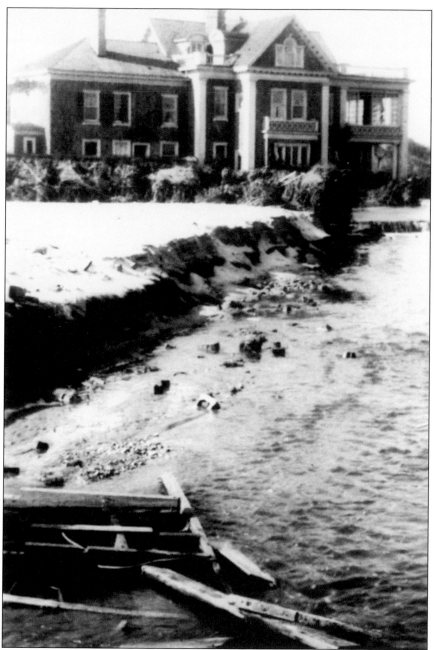

The cottage of Mrs. George DeWitt, where the group from the Bathing Corporation sought refuge, sits overlooking the destruction where the storm surge created a temporary inlet between the ocean and Lake Agawam. Lifeguard Dan Ferry had gained the porch of the house when he saw a wave carrying Della Johnson away from the group, and he made his unsuccessful attempt to rescue her. While he was battling his way to shore, the others in the group found the door to the DeWitt cottage open and made their way to the second floor where they managed to find dry clothes and blankets and survived. The next morning, when the water had receded, the bodies of Della Johnson and Florence Hunter were found within 30 feet of each other on the east side of the lake. (Courtesy Southampton Historical Museum, Barbara Lord.)

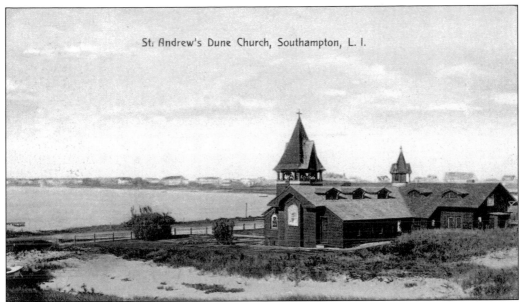

St: Andrew's Dune Church, Southampton, L. I.

St. Andrew's Dune Church, scene of many Southampton society summer weddings, was founded in 1879 when a small group from the summer community purchased an old life-saving station and moved it to a site on the dunes opposite Lake Agawam. This early view of the church was taken from the ocean side looking toward the lake back in the days when most worshipers arrived by horse and carriage, although one family famously came across the lake in a gondola. (Courtesy Eric Woodward collection.)

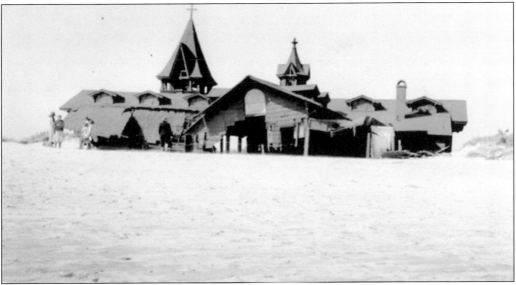

When its protective dune was leveled, St. Andrew's Dune Church was exposed to the full fury of the hurricane. The walls of the south transept and the south wall of the nave were smashed by wind and waves. The choir house was demolished and the concrete blocks used in its construction became battering rams to beat against the church. The organ was later found floating 1,000 feet from the church. Pews were pushed aside and several of the church's exquisite stained-glass windows, some by Louis Comfort Tiffany, were shattered. (Photograph by Richard M. Johnson.)

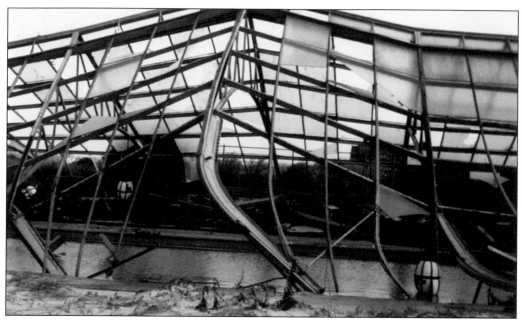

After the hurricane, twisted metal and shattered glass were all that remained of the enclosure that had so handsomely housed the spectacular swimming pool at Wooldon Manor, the oceanfront estate built by James P. Donahue's wife Jessie Donahue (née Woolworth). According to local lore, the pool's extravagant design was intended to humble the Bathing Corporation next door, which had rejected the family for membership because the Donahue fortune derived from the déclassé F. W. Woolworth five-and-dime chain. The pool was not only bigger and better than the club's, it was covered with violet-ray glass priced at $25 per pane. (Courtesy George Haddad, Ron Ziel collection.)

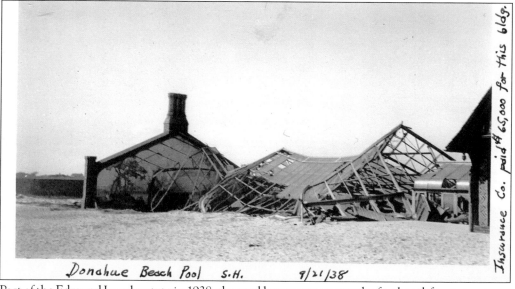

Donahue Beach Pool S.H. 9/21/38

Insurance Co. paid $65,000 for this bldg.

Part of the Edmund Lynch estate in 1938, the pool house was among the few beachfront structures that was properly insured. That it was covered at all was remarkable. That its destruction obliged the insurance company to pay out a whopping $65,000 was even more remarkable, and the photographer who took this shot made a point of recording the unprecedented payout at the edge of his image. (Photograph by Richard M. Johnson.)

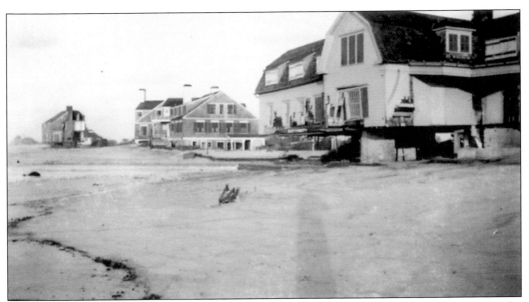

Although these houses, west of St. Andrew's Dune Church, remain standing, the two in the foreground—J. F. Byers's Sandymount and the Stewart cottage—have been badly undermined by the hurricane, while the structure in the far distance is actually just half of the cottage owned by Dorothy Schieffelin. The other half was ripped away in the storm and carried across the road, where it came to rest on the lawn of the landmark Old Mill House. (Courtesy Southampton Historical Museum.)

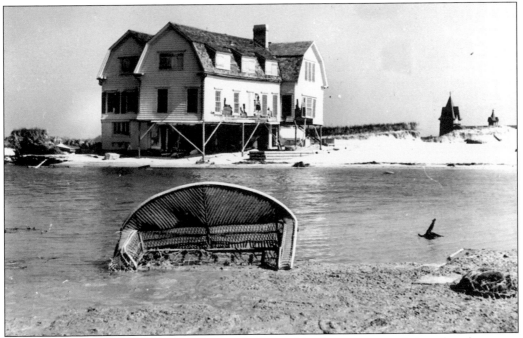

A wicker love seat has been unceremoniously dumped in the waters remaining after the ocean rushed over the dunes at Sandymount, opening a temporary inlet between the Atlantic and Lake Agawam. When the waters receded, the beach was littered with the refuse of carefree summer living. (Courtesy George Haddad, Ron Ziel collection.)

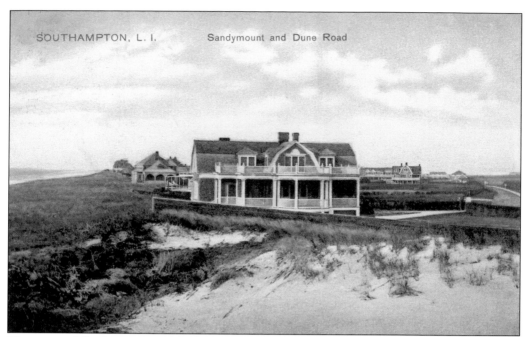

This view of Sandymount as it looked some two decades before the hurricane struck shows the handsome cottage safely tucked into the dunes between the momentarily placid waters of the Atlantic on the left and Dune Road (Gin Lane) on the right. (Courtesy Eric Woodward collection.)

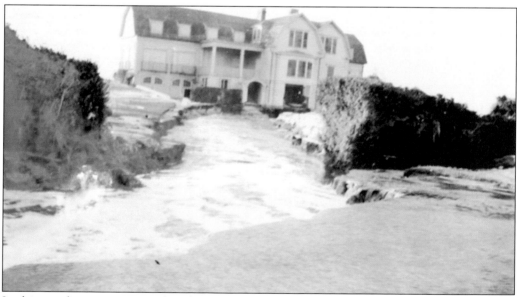

In this post-hurricane view, taken from the road, the gash cut through the dunes still flows with ocean water. The house has been swamped and the manicured lawn and well-trimmed privet of the earlier view have both taken a beating. (Photograph by Richard M. Johnson.)

34

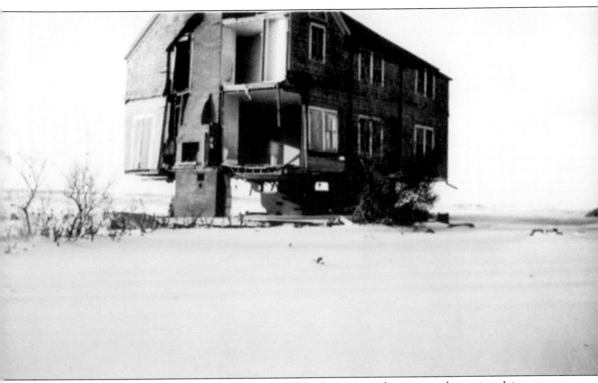

After the storm, the west portion of the Schieffelin house stood precariously on its chimney foundation and a fragment of its wall. When the east portion was torn away, interior rooms of the section left behind were exposed like those of a dollhouse. Meanwhile, ripped from its foundation, the east half of the house was swept over the road by the roiling waters that had breached the dunes and came to a stop alongside the quaint Old Mill House, where its journey ended. When the waters receded, the scene was a hodgepodge of errant eaves, displaced porches, houseless roofs, and roofless houses. For many, repair or reconstruction was not an option. The prognosis for the Schieffelin house was a dismal one, but the Old Mill House, already a landmark for more than 50 years at the time of the hurricane, survived the storm and continues to attract admiring attention. (Courtesy Southampton Historical Museum.)

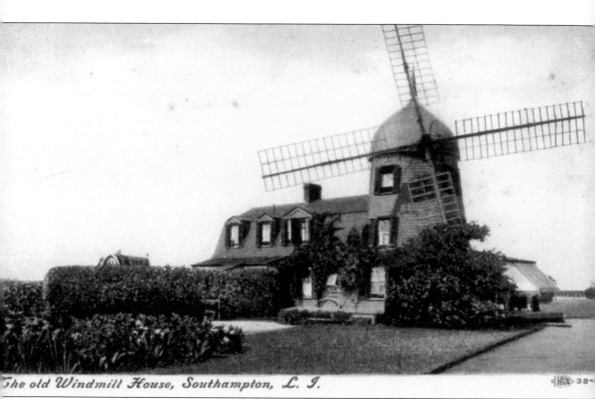

*The old Windmill House, Southampton, L. I.*                    38

C. Wyllys Betts and his brother Frederick were prominent pioneers of the Southampton summer colony. Both were founders of St. Andrew's Dune Church and both built houses on the west side of Lake Agawam. When the Frederick Bettses took a trip to Venice, they returned with the gondola that delivered Mrs. Betts to St. Andrew's Dune Church every Sunday, thanks to the efforts of the family's four footmen, who poled the extraordinary vessel across Lake Agawam. In 1880, brother C. Wyllys created this equally eye-catching cottage on one of his properties on Dune Road (Gin Lane). After purchasing the old windmill at Good Ground (now Hampton Bays), he moved it to its new Southampton location, where he remodeled it and attached it to a cottage, creating this highly picturesque summer retreat. The Betts brothers had extensive holdings in the village and owned several cottages, which they often rented out to their friends. One story accounting for the proliferation of Betts cottages holds that C. Wyllys Betts was such an obsessive collector of English furniture that he accumulated enough of it to fill seven houses. At that point, his brother declared, "Now I'll have to build you seven houses." (Courtesy author's collection.)

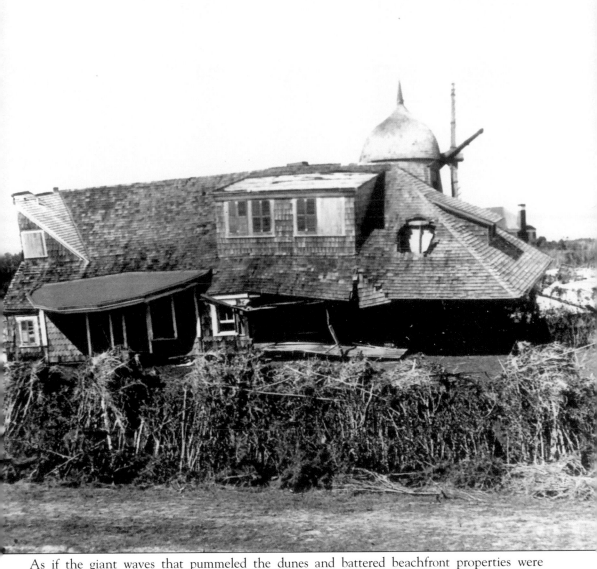

As if the giant waves that pummeled the dunes and battered beachfront properties were not enough, the storm surge—that towering wall of water that survivors recalled with such terror—was infinitely worse. Powerful enough to rip this chunk of the Schieffelin house from its foundation and carry it across the street, the storm surge was a tidal wave in all but name, that term being reserved for an earthquake-generated swell. Surges are created when hurricane winds push water into the storm's center. While the storm is out at sea the water can spread out and flow away. This release is no longer possible as the ocean floor rises near land and the waves pile up on each other, then crash on the shore. It is these storm-driven surges that typically cause the most dramatic destruction and account for a majority of the fatalities in a hurricane. In 1938, the storm surge struck east of the eye, where the strongest winds pushing up from the south drove into the exposed coastline. The first big wave was followed by others. Doubling the height of a wave quadruples its power; triple the height and its strength is increased nine fold. One cubic yard of water weighs roughly three-quarters of a ton. The jolt from the first surge registered on seismographs in Alaska. (Courtesy Southampton Historical Museum.)

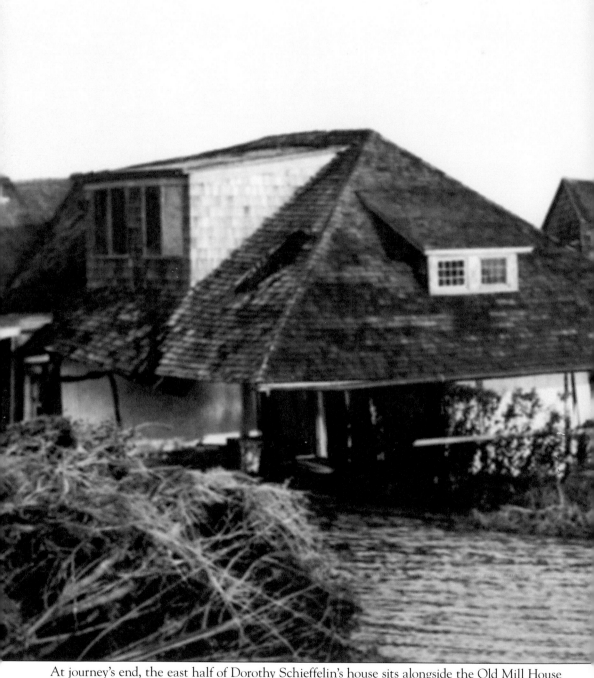

At journey's end, the east half of Dorothy Schieffelin's house sits alongside the Old Mill House where it was washed by waters that poured through the dunes. The Old Mill House had a happier fate, surviving the storm and remaining a favorite destination for sightseers who are charmed by its quaintness, as was a correspondent for the *Evening Post* who visited Southampton in 1880. He described the cottage, only recently completed at the time and occupied for the summer by one

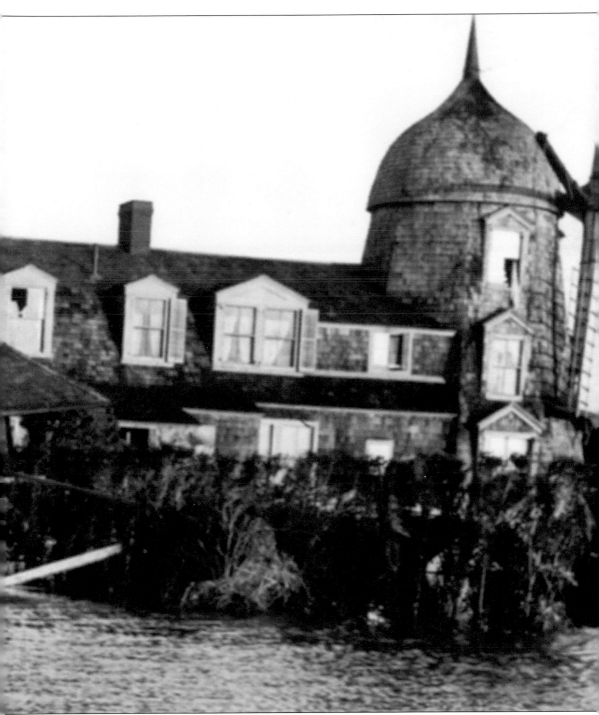

Colonel Jay, as "a highly picturesque affair, having for a tower the old-fashioned Dutch windmill which you traveling readers may recall as once standing close to the railway at Good Ground Station a few miles from here. Mr. Betts bought it, pulled it up by the roots and transplanted it   sails and all." (Courtesy Southampton Historical Museum, Barbara Lord.)

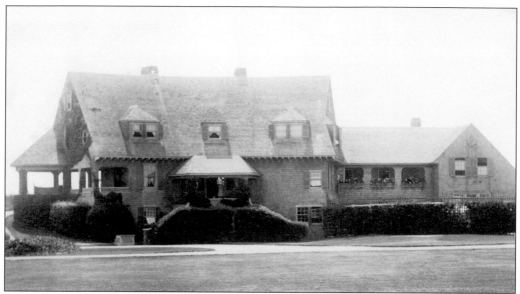

The house that McKim, Mead and White designed in 1886 for Charles R. Henderson, the only Southampton cottage the firm did in the simple shingle style, was utterly demolished by the hurricane, its pieces flung onto the lawn of the nearby Meadow Club. Boldly sited atop a dune, White Caps was labeled "a characteristic Dune House" in an illustration that appeared in *Harper's Weekly* in August 1892. It had a corner porch tower, an internal open verandah, three dormer windows that extended through the roof, and a porthole window on the eastern side. (Courtesy Eric Woodward collection.)

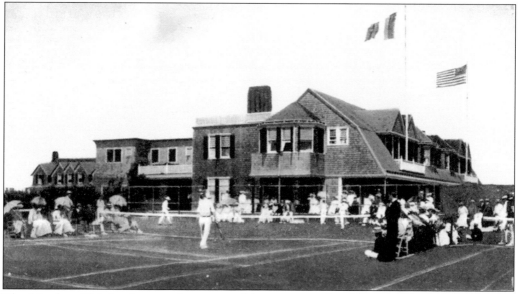

The Meadow Club has been at the center of the summer colony's social and sporting life since its earliest days. Founded in 1887, just 15 years after lawn tennis was first introduced to America, and at a time when Southampton was burgeoning into a fashionable summer resort, it boasts world-class grass courts and a reputation for exclusivity. After the hurricane, sample blades of the ruined grass were sent to Washington for analysis until, finally, the proper type was identified and replanted. (Courtesy Southampton Historical Museum.)

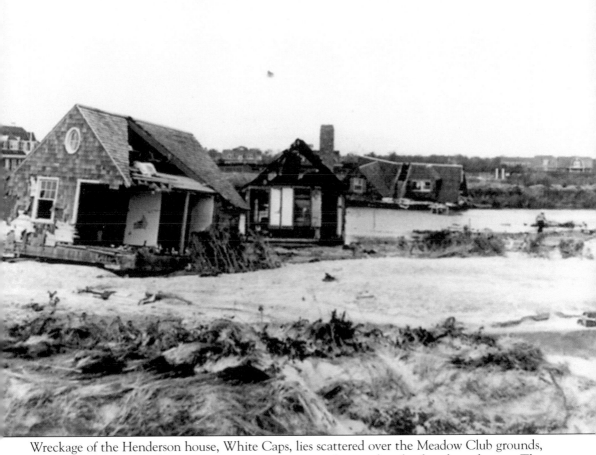

Wreckage of the Henderson house, White Caps, lies scattered over the Meadow Club grounds, where the club's magnificent grass tennis courts were submerged under four feet of water. The clubhouse, far left, sustained considerable damage while several outbuildings and a cottage were totally destroyed. The Meadow Club Tea House, a popular summer rental then occupied by Oliver and Clara Lee Rodgers, was badly undermined. In the years since the club's founding, the modest original clubhouse had given way to a bigger, more elaborate building with facilities for dining and private parties that made it the popular gathering place for member families and their guests that it remains today. For 85 years, from 1888 to 1973 (minus several exceptional years when it was not held), the annual invitational tennis tournament was a highlight of the summer season, bringing the highest ranked players to compete in Southampton. The list of tennis stars who played at the Meadow Club is a virtual who's who of the tennis world; among them are Bill Tilden, Sidney Wood, Pancho Gonzalez, Tony Trabert, and Arthur Ashe, to name but a few. During the tournament the long porch that faces eastward toward the courts was the place not just to see but to be seen. (Courtesy Southampton Historical Museum.)

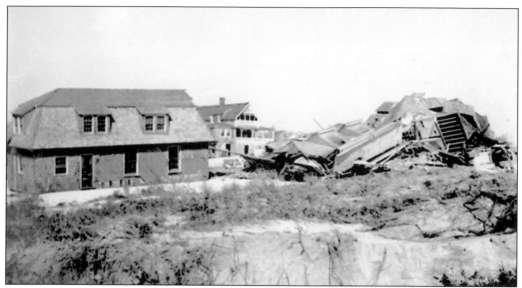

Between the Bathing Corporation at the south end of Lake Agawam and the municipal beach (Cooper's) at the end of Cooper's Neck Lane, only two cottages remained standing after the sea swept over the dunes and crossed the road. This shot, taken on September 21, illustrates the range of damage inflicted by the category 3 hurricane. The structure on the left appears to be incomplete; the cottage in the background may have survived almost intact, while the original profile of the pile of debris on the right is anyone's guess. (Photograph by Richard M. Johnson.)

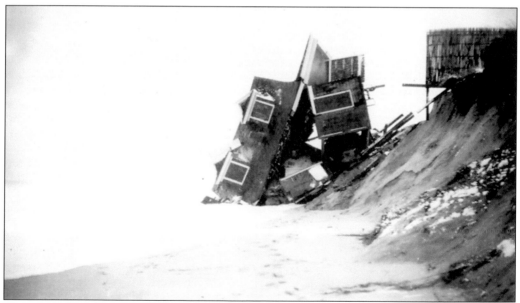

This oceanfront house in Southampton was toppled unceremoniously from its gouged-out dune into the surf. The hurricane's timing could not have been more unlucky as high tide was even higher than usual because of the Autumnal Equinox and new moon. Combined with winds that gusted to more than 100 miles an hour and waves between 30 and 50 feet high that pounded the coastline, it is no wonder that entire homes were swept into the sea. (Courtesy Southampton Historical Museum.)

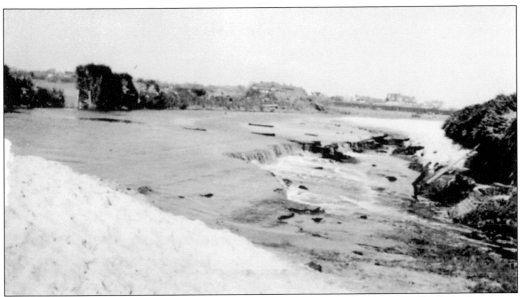

Tides that abetted the storm were the highest seen in more than 100 years and where the dunes were breached, as they were here in Southampton where Lake Agawam meets Dune Road, the merging of ocean and lake was catastrophic. Tons of sand dumped by the surging ocean water almost obliterated the road, and although privet and other vegetation in its path appeared at first to have weathered the storm, in the long term, plants that had been submerged or heavily sprayed with salt were doomed. (Photograph by Richard M. Johnson.)

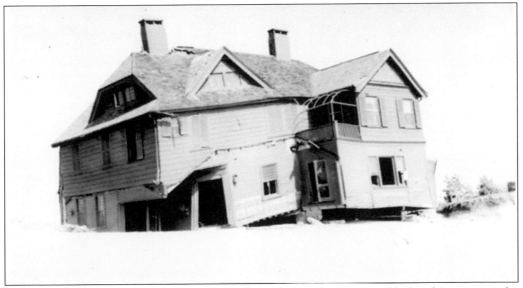

As late as noon on the day of the hurricane, the radio weather report told of nothing more to be expected than "shifting easterly gales." At mid-afternoon, when the storm struck, most people did not realize that a hurricane was upon them even as the waters began flooding their coastal homes. While this Southampton beach house had very likely been vacated for the season, many of those who had lingered in hopes of wringing a bit more summer from the season later described having been taken totally by surprise when waves began beating at their windows and water began oozing under their doors. (Photograph by Richard M. Johnson.)

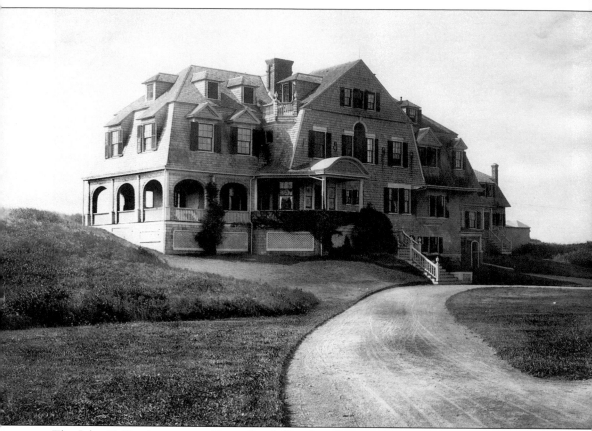

The John F. Harris estate on Dune Road (Gin Lane), somewhat ironically named Stormalong, was among the most imposing of the summer homes in Southampton, which were coyly referred to as cottages. In a style that had originated as a deliberate effort on the part of the prosperous professionals and businessmen, who predominated among the pioneers of the summer colony, to display a modest, family-oriented sensibility in contrast to the frivolity and ostentatiousness that prevailed in places like Newport, the first summer cottages were relatively simple. By 1915, however, the approximate date of this view of Stormalong, simplicity had succumbed to extravagance. Front porches and side porches, elegant entryways, ornate parlors, sitting rooms, guest rooms, and numerous maids' rooms all were features of the bigger, more elaborate seasonal retreats that were rarely occupied for more than 10 weeks of the year. (Courtesy Eric Woodward collection.)

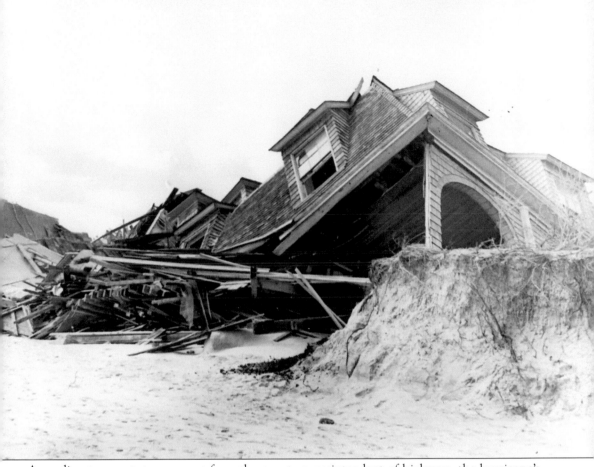

According to a post-storm report from the county superintendent of highways, the hurricane's most costly effect on public property in Suffolk County was the damage it did to the dunes. Here the gouged and flattened remains of the dune that had provided such a graceful setting for the Harris house tell the story. The report noted that the dunes of Long Island were diminished by 90 percent when their sand was blown away by the storm's high winds or swept inland by the abnormal tides. (Courtesy Southampton Historical Museum.)

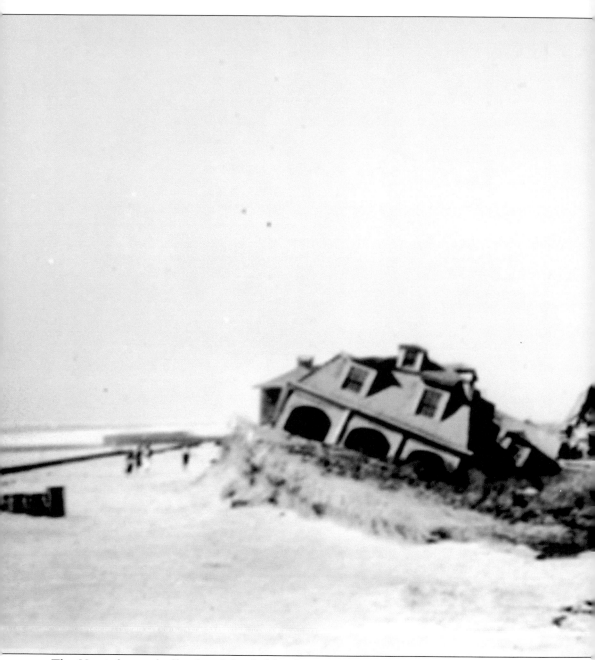

The Harris house, buffeted and flooded by the titanic waves, was completely wrecked by the hurricane. Unlike its neighbor, the Henderson house, which floated away, Stormalong collapsed on the spot, its elegant arched porch tilting crazily into what remained of the dune it had so grandly dominated. There were odd contrasts in the degree of destructiveness inflicted on neighboring houses and the hurricane performed some strange tricks. One cottage was completely turned

around and placed upright, but the lamps on the tables were undisturbed and a jug of water in the kitchen sink remained right side up. Not far away, a fresh egg, whole and uncracked, was found resting gently on a pile of debris. Many trees that were bent downward and partly uprooted by the first blow of the hurricane were later raised back upright and restored to their original position when the wind shifted. (Photograph by Richard M. Johnson.)

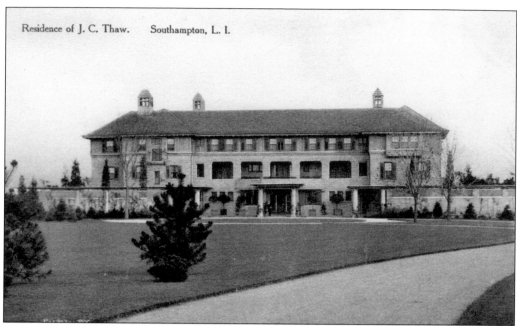

Residence of J. C. Thaw.     Southampton, L. I.

The massive residence of Josiah Copley Thaw, Windbreak, built in 1911, had a commanding view of the Atlantic from its perch on the dunes. Its sweeping lawns and gardens were the work of Beatrix Ferrand, the only woman among the 11 founding members of the American Society of Landscape Architects and a favorite in high society circles. Those circles were shocked when Josiah's brother, Harry K. Thaw, irreparably tainted the family name in 1906, when he gunned down architect Stanford White. (Courtesy Eric Woodward collection.)

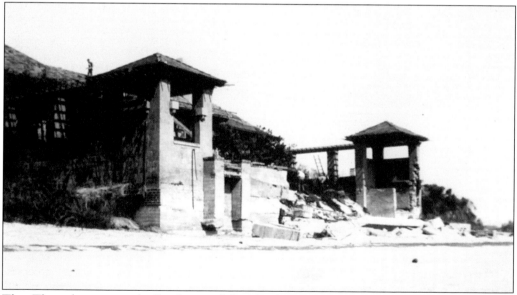

The Thaw house was badly damaged by the hurricane, as this view of the imposing Mediterranean-style residence, taken from the beach side, clearly illustrates. Although sections of its fortress-like construction stood fast against the surging sea, pieces of the mighty house, which had seemed built for eternity, were snatched by the sea and floated away. (Courtesy Southampton Historical Museum, Sheila Guidera.)

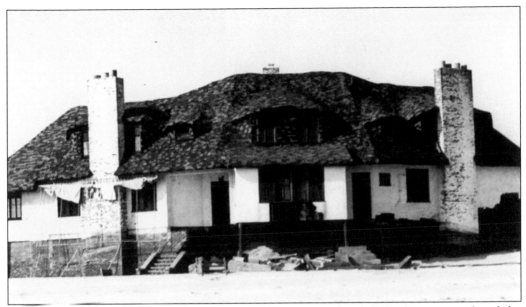

While the section of Southampton where the Atlantic merged with Lake Agawam produced the most dramatic evidence of the hurricane's fury, the strip of coastline stretching west from the municipal beach toward the ocean breach at Shinnecock was not spared. The H. Denny Pierce cottage, with its picturesque ersatz thatch roof, occupied at the time by Mrs. Livingston Fairbank, was badly battered but survived. (Courtesy Southampton Historical Museum, Barbara Lord.)

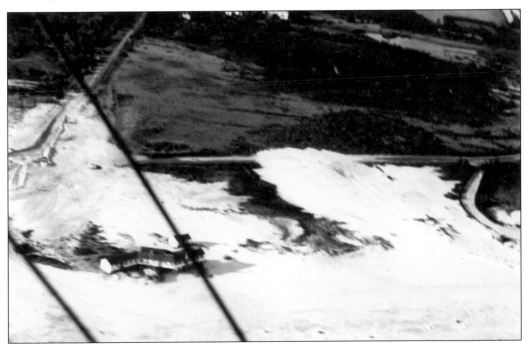

Dr. Joseph Wheelwright's house on Meadow Lane is visible on the left in this overview of a section of the beachfront west of the municipal beach. It was severely battered and appears to have been more or less stranded at the height of the storm, but it somehow survived. (Courtesy Southampton Historical Museum, Barbara Lord.)

Edward P. Mellon's Villa Maria on the Southampton dunes was damaged by the hurricane, but not seriously. Mellon, an architect and member of the eminent banking family, designed the house for his own use and built it on the narrow finger of barrier dunes between the Atlantic and Shinnecock Bay around 1918. With its stucco walls and terra cotta tiles, the house was intended to evoke the romance of an old Tuscan villa. Decorative ironwork was imported from Italy and the marble floors were recycled from old buildings. Among Mellon's better known commissions was his design for the tomb for Pres. Warren G. Harding in Marion, Ohio. Another client was Duncan Ellsworth for whom he designed Mylestone just down the road. Built a few years after Villa Maria, it too survived the hurricane with no serious damage. Designed in a cottage style that contrasts with the Tuscan fantasy Mellon built for himself, it was substantially altered in later years. (Courtesy Southampton Historical Museum, Barbara Lord.)

Henry Francis du Pont's Chestertown House, built in 1925 on the same fragile strip of Southampton dunes as Villa Maria, survived the hurricane without a scratch although the ocean broke through to Shinnecock Bay between the house and the garage leaving a great gash to be filled. The handsome brick Georgian-style house was designed by the architects of choice among New York City's social elite, Cross and Cross, for their client, who was considered the nation's preeminent collector of early American decorative arts. The gardens were designed by Marian C. Coffin near the start of her illustrious career as a landscape architect. Unfortunately a subsequent owner of the house scandalized neighbors and tastemakers by enveloping its dignified exterior in a fanciful Gothic carapace. As Barry Trupin's dream castle, Dragon's Head, it became a nightmare for the village of Southampton, which spent several years and considerable sums of money in an attempt to rein in a design that was deemed to have exceeded not only the limits of good taste but those of the law. When he purchased the house in 2003, the designer Calvin Klein took on the task, vowing to subdue the structure's excesses. (Courtesy Southampton Historical Museum, Barbara Lord).

Nothing but heaps of ruins remained of Justin O'Brien's two houses, East Wind (above) and West Wind (below). Located at a point where the ocean carried everything before it and left sand waste clear through to the bay, the houses did not stand a chance. The road between the dunes and the bay almost completely disappeared, some parts having been washed out, others simply covered by sand. Those who lived through the storm remember a wind and uproar of indescribable fury. They watched substantial buildings like these being lifted from their foundations, collapse, or explode into fragments that flew away downwind. Clocked at 90 miles per hour with gusts of over 100 miles per hour, the wind at the start of the storm was from the southeast, blowing warm, wet, and thick with flying debris. Small items, principally shreds of leaves torn from the trees, were blown almost horizontally through the murk. (Photographs by Richard M. Johnson.)

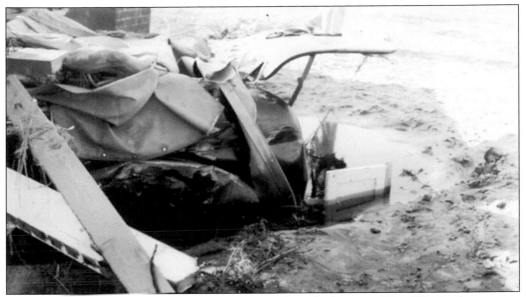

The Buick belonging to Dr. Niles fared no better than the house at West Wind, where it was pummeled, crumpled, and half buried in sand. The hurricane reached its crisis point between 4:00 and 5:00 p.m. as the eye passed over the area. The southeast wind diminished to a temporary calm before winds from the southwest gained hurricane force and the storm continued on its path of destruction. (Photograph by Richard M. Johnson.)

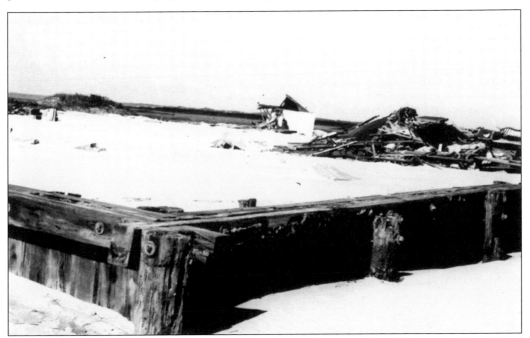

By 5:30 p.m., the hurricane was over, leaving the bulkhead at East Wind and West Wind exposed and an expanse of sand where once the two houses had stood. When daylight faded, the Hamptons faced the darkest night the area had known since earliest days with all electricity cut off and lamps and candles in short supply. (Courtesy Southampton Historical Museum, Barbara Lord.)

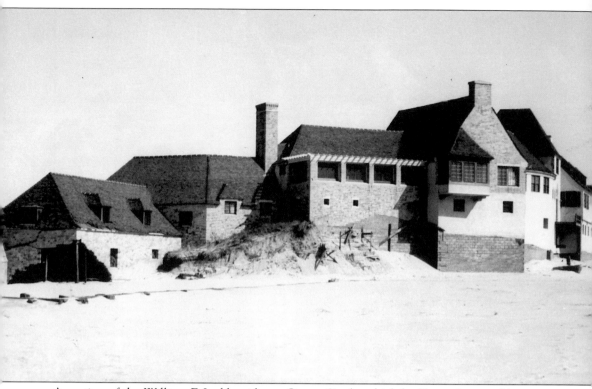

A section of the William F. Ladd residence Ocean Castle, which had been destroyed by a severe storm in 1931 and subsequently replaced, was undamaged by the 1938 hurricane. The later storm did not spare the older part of the house, however, which was undermined. Inspired by a neighboring studio, which the society architect Archibald Brown had built for his wife, the Ladds had asked Brown to design a dune house for them in 1929. In 1938 it was repaired once again and still stands. The house has a colorful history, having made the news as the site of an infamous party in 1963, when society's gilded youth trashed it and *Life* magazine covered the story. Then, in 1978, the eccentric theater producer Roy Radin put it in the news again with his wild, drug-fueled parties. Now it has shed its unsavory past and is known simply as one of Southampton's most elegant beach houses. (Courtesy Southampton Historical Museum, Barbara Lord.)

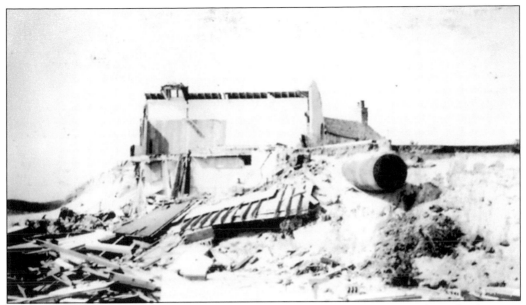

The Brown studio, which had so impressed the Ladds, fared much worse than the house it inspired. "The beautiful studio cottage of Mr. Archibald M. Brown is completely ruined," lamented a local reporter, whose account in the newspaper's edition of September 23 continued: "The cottage stood on a high dune and was considered safe from any storm. The tidal wave leaped the protecting bulkhead and in an incredibly short time had toppled most of the house down the bank."

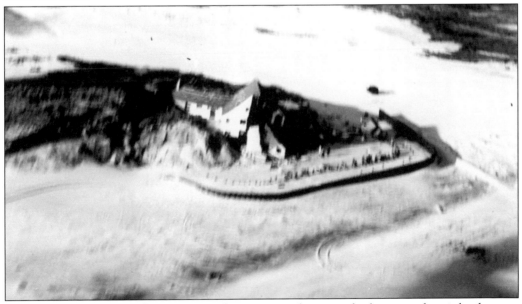

This aerial view shows the Brown studio precariously situated where another inlet has cut through to the bay. Indeed, as the newspaper account relates, "Both east and west of the house great inlets formed through which the ocean waters rushed into the bay." That apparently saved the Browns' neighbor Harry Towle's house since the breach dissipated the force of the water where the newly built structure "suffered not the least injury." (Courtesy Southampton Historical Museum, Barbara Lord.)

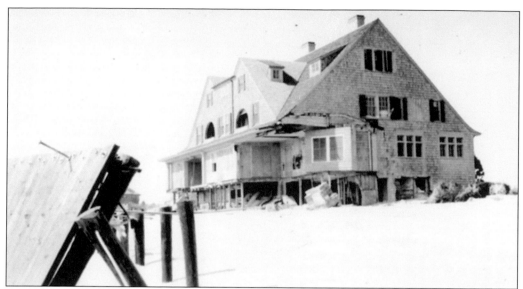

Many of the shorefront houses east of the Bathing Corporation and the St. Andrew's Dune Church came through the hurricane with little damage. Others did not. Eden Cottage, the beachfront home built by Pierre Lorillard of the tobacco family, was hard hit on the ocean side but survived to weather many more storms and remains on the site. (Photograph by Richard M. Johnson.)

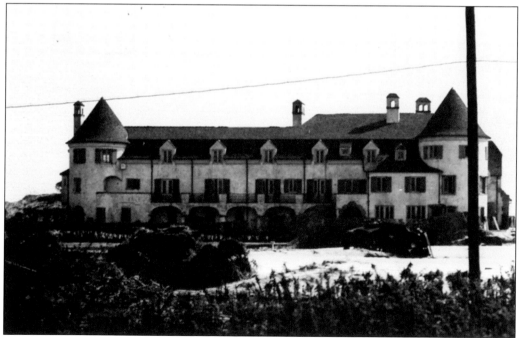

The Moorings, L. Gordon Hammersley's palatial estate at Gin and Wyandanch Lanes, was irreparably damaged when the ocean washed right through the house. Members of the Hammersley family and some of their household staff endured a harrowing experience awaiting rescue by boat. Their lives were saved but just about all of their belongings—furnishings, automobiles, and other treasures—were lost. (Courtesy Southampton Historical Museum, Barbara Lord.)

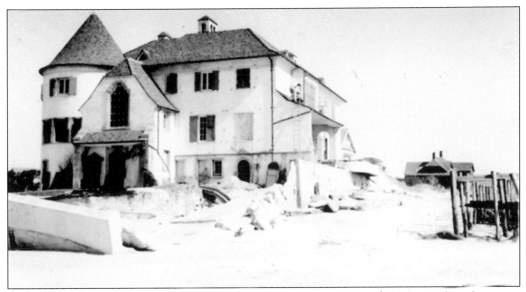

The Moorings, L. Gordon Hammersley's estate, seen from the road, looks as though it may have suffered nothing worse than the thick blanket of sand that choked its lawns and filled the roadway, but this view from the beach side tells another story. Here the crumpled concrete and exposed interior are testimony to the force of the water as it rushed over the dunes. (Photograph by Richard M. Johnson.)

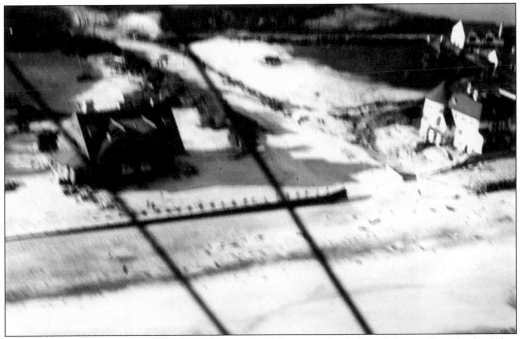

Wind and water carried tons of sand past the Moorings (right) and Pierre Lorillard's Eden Cottage (left), as seen in this aerial view taken shortly after the hurricane ended. Sand covered Gin Lane and traveled down Wyandanch Lane, leaving only flat beach between the houses and the unpredictable sea. (Courtesy Southampton Historical Museum, Barbara Lord.)

# MONTAUK

### SCALE

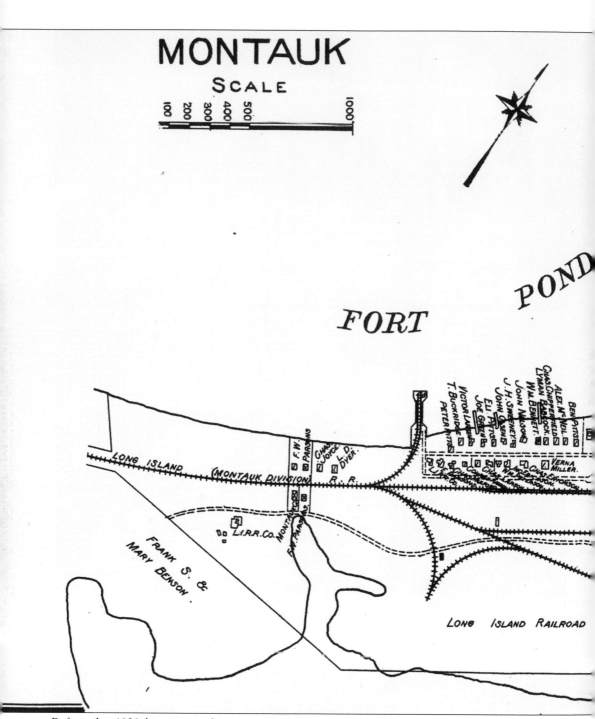

Before the 1938 hurricane, the Montauk fishing village (map above) was a thriving hub of activity, while downtown Montauk as it exists today was still in the future. Small houses, many made from the huge fish boxes used to ship the fishermen's catch to New York's Fulton Street Market, lined the road that ran parallel to the Fort Pond Bay shoreline. There were restaurants and a post office, and, as one resident put it, "This was town." When the hurricane struck, the ocean breached the narrow strip of land at the tip of the South Fork, cutting Montauk off from

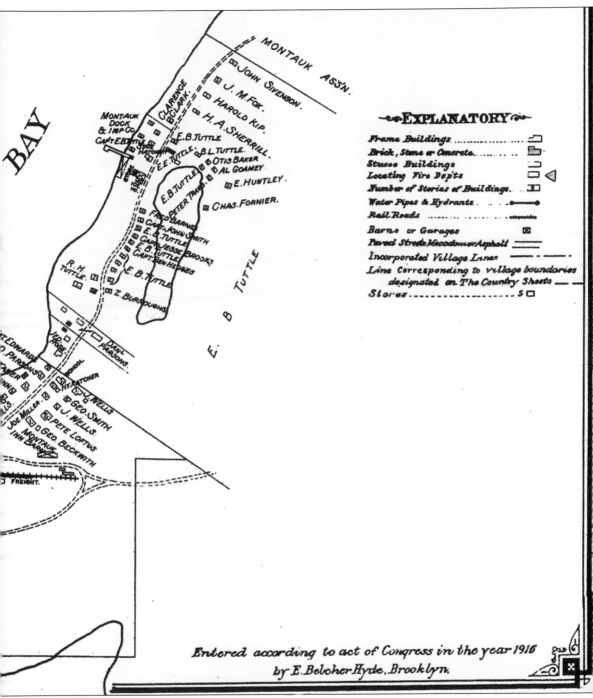

BAY

MONTAUK ASS'N.

MONTAUK DOCK & IMP Co.

CLARENCE B. CLARK

CAPT E.B. TUTTLE

JOHN SIVENSON.

J. M. FOX.

HAROLD KIP.

H. A. SHERRILL.

E.B. TUTTLE.

E.E. TUTTLE.

B.L. TUTTLE.

OTIS BAKER

AL GOAMEY

E. HUNTLEY.

E.B. TUTTLE.

PETER TRAPP

CHAS. FORNIER.

FRED BARNS

CAPT. JOHN SMITH

E. B. TUTTLE

CAPT. JESSE BROOKS

CAPT. B. TUTTLE

CAPT. BEN HEDGES

R. H. TUTTLE.

E.B. TUTTLE.

Z. BURROUGHS

DAN PARSONS.

E. B. TUTTLE

EDWARDS

PARSONS

GER

THATCHER

J. WELLS

GEO. SMITH

JOE MILLER

J. WELLS.

PETE LOFTUS

GEO. BECKWITH

MONTAUK INN BARN

FREIGHT.

—•◦ EXPLANATORY ◦•—

Frame Buildings ............................

Brick, Stone or Concrete .............

Stucco Buildings

Locating Fire Dep'ts

Number of Stories of Buildings .

Water Pipes & Hydrants . . . .•——•

Rail Roads .......... . . . . .

Barns or Garages

Paved Streets Macadam or Asphalt ═══

Incorporated Village Lines ——·——·

Line Corresponding to village boundaries
    designated on The Country Sheets ── ─

Stores ............................. S ▢

*Entered according to act of Congress in the year 1916
by E. Belcher Hyde, Brooklyn.*

the mainland and flooding Fort Pond. Initial reports that the entire fishing village had been swept away and that the Montauk Lighthouse itself was in danger turned out to be exaggerated. The lighthouse was apparently never seriously threatened and the fishing village was not destroyed, but the damage to houses and vessels was devastating and the bayfront community never regained its former vigor. (Courtesy Montauk Library.)

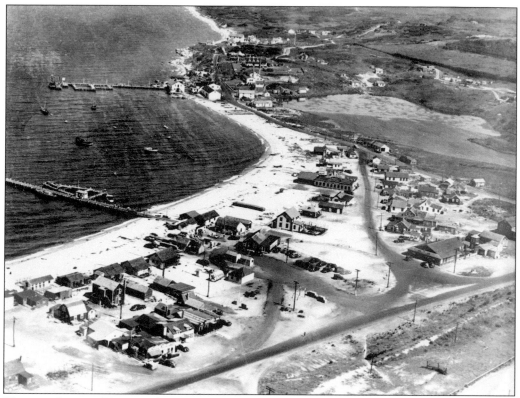

This aerial view of Fort Pond Bay and the Montauk fishing village predates the hurricane. From East Hampton to the east, it was fishermen who paid the storm's toll, although the number of men who died at sea remained uncertain for some time. About 100 houses were seriously damaged, leaving 150 from the village homeless. (Courtesy Montauk Library.)

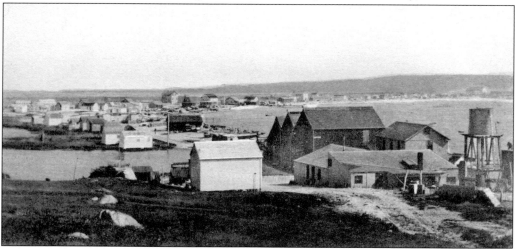

Three major fishing stations were established in Montauk in the 1880s. Capt. E. B. Tuthill (whose business Perry Duryea Sr. bought) founded this one on the east side of Fort Pond Bay. Capt. J. C. "Jake" Wells founded another on the southern edge of the bay, and Capt. Frank Parsons built his west of what was called the railroad dock at the easternmost terminus of the Long Island Rail Road. (Courtesy Montauk Library.)

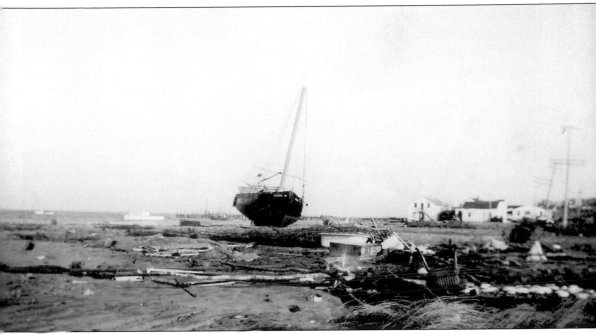

In Montauk, the hurricane left more than 80 fishing boats in an unsalvageable state. The boat above, *Angler*, was blown ashore, as were 28 others that lay from 100 to 300 feet up the beach. Some were worth as much as $25,000 and would cost a fortune to relaunch. Scores of dragnets and fish traps, some valued at as much as $10,000 each, were obliterated. The oyster and clam industry was also devastated as tons of sand smothered the entire harvest. Around Fort Pond, the South Fork is only a half mile wide from north to south and when the wind and water began to blow in from the ocean the area quickly became a swamp. Cut off by water, which had also breached the narrow Napeague stretch to the west, Montauk was a virtual island, isolated from the time the hurricane struck until September 23. All power and lights were lost and the storm tore up miles of track along the Long Island Rail Road. Near Montauk Point, even the roadbed was obliterated. (Courtesy Montauk Library.)

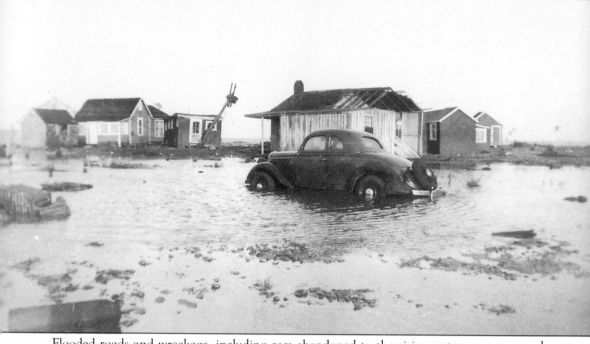

Flooded roads and wreckage, including cars abandoned to the rising waters, were everywhere in the aftermath of the hurricane. The damage might have been less severe had Montauk not had the bad luck to be hit by the northeastern arc of the oncoming storm, well known to sailors as the most dangerous quadrant of a hurricane. That and the incredible forward speed of the 1938 storm—the fastest that had ever been recorded—spelled disaster for everything in its path. Because hurricane winds rotate counter-clockwise, the winds to the east of the eye are moving from south to north, and because the hurricane was also moving in the same direction, the forward speed added clout to the already powerful winds. Making matters worse were high tides—due in just a few hours—that were even higher than usual because of the Autumnal Equinox. By the time they realized what was upon them, Montauk residents had no options but to flee to higher ground. (Courtesy Montauk Library.)

# *Two*

# RAVAGED VILLAGES

Once the dunes had given way before the terrible force of the roaring surf, it was only a matter of minutes before shopkeepers and shoppers on Main Street in Westhampton Beach saw a wall of water coming their way. Moving swiftly and carrying debris from the dunes, the storm surge quickly put downtown Westhampton Beach under almost six feet of water. It dumped yachts onto residents' front lawns, battered their houses, crushed their cars, and toppled their trees.

Westhampton Beach was unique in experiencing such severe flooding but in most other respects the hurricane exacted the same terrible toll from East End villages eastward to Montauk, catching everyone by surprise. When the storm struck without warning, village children were in their schoolrooms, movie houses were showing Wednesday matinees, and shops up and down Main Street were doing business as usual. Village life was following its normal course.

It would be a long time before life would return to normal, and in some ways downtown landscapes would never again be the same. Village streets that had been lined with ancient elms on September 21 were opened up to the sky on September 22, while underfoot the felled trees that had shaded them lay where they had crashed to the ground in heartbreaking numbers. Most of the houses would regain their dignity with repairs but the missing trees would leave their handsome old neighborhoods looking sadly denuded for years to come.

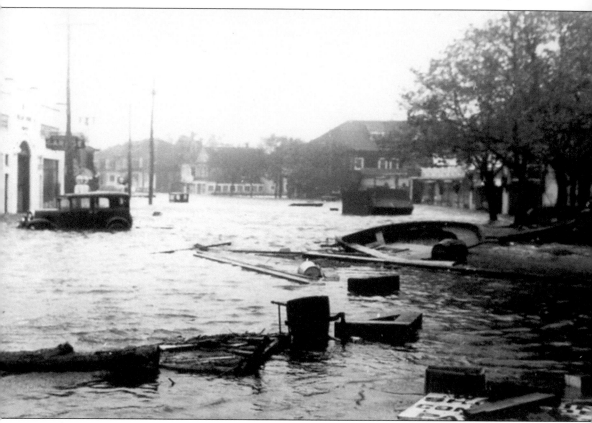

The swiftness with which the storm surge covered the ground between the beach and Main Street in Westhampton Beach took shopkeepers and customers by surprise. Here, in this view looking west on Main Street, which was taken when the water had receded somewhat from its peak of about six feet, the debris it brought with it is seen scattered in the foreground. In the background, beyond the trees, is Schwartz's Department Store. Everything, from chairs to barrels and beams, was dumped on the street. Among the hurricane reminiscences collected by the Quogue and Westhampton Beach historical societies, is Ria Del Bene's. She remembered running down Main Street to see what was happening and watching the water being drained out of the Moniebogue Canal. She stayed to see it reverse course and rise up over the meadows south of Main Street before realizing the danger and running back home to Sunset Avenue. There she watched the water "flow past the back of our property like a river." It was fortunate, she said, that the family had moved a few years earlier from their former Main Street home next to what was then Mike Parlato's Garage (and later housed the nightclub Marakesh). "That part of Main Street is the lowest," notes her account, "and the flood water was six or seven feet high in all those buildings." (Courtesy Westhampton Beach Historical Society.)

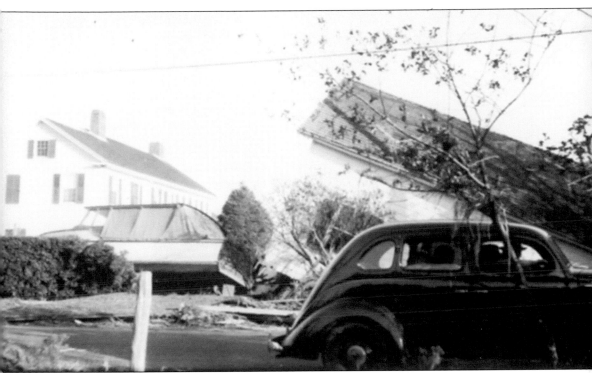

As the hurricane passed over Westhampton Beach, it rearranged what had been, just a few hours earlier, an orderly landscape of houses ranged along tree-lined streets, boats tidily moored in sheltered waters, and automobiles parked in the customary places. By late in the day on September 21, the landscape looked more like a surrealist's dreamscape. The greater part of the village had been underwater and many inland houses were wrecked by the wind and the rains. Cars were tumbled like leaves and deposited far from their point of departure. A large yacht was left high and dry as far inland as Montauk Highway at Cook's Pond, and many other boats were dumped in unlikely places; in meadows, in a churchyard, in the woods, and alongside village houses, like the one above. The Beach Lane and Library Avenue portions of the village were jammed with wreckage from the disintegrated houses that had stood on the dunes. The number of cars disabled on the dunes and in parts of the village within a half mile of the bay shore amounted to several dozens. The shiny vehicle in this photograph was almost certainly driven by an early sightseer from higher ground. (Photograph by Richard M. Johnson.)

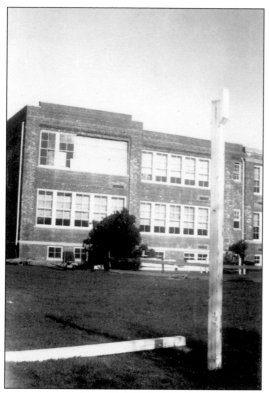

The local school in Westhampton Beach at Six Corners had become too small to accommodate the growing population of schoolchildren in 1938 and a new high school was under construction at the time of the hurricane. This photograph shows the original schoolhouse, where some 200 students were in the building as the storm approached. The first-floor classrooms were inundated to a depth of nearly five feet and many windows were blown in. In this photograph, the holes they left have already been boarded up. (Courtesy Westhampton Beach Historical Society.)

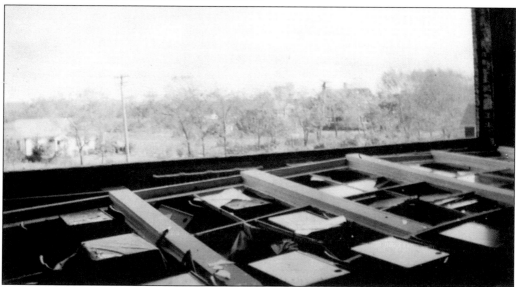

Art teacher Miriam Harmon was in the Six Corners school when the storm hit. In her reminiscence for the Quogue and Westhampton Beach Historical Societies, she recalled that "several windows were blown in, thereby admitting plenty of wind and more than plenty of water and then the whole wall of the room above mine crashed. . . . Wherever anything happened, the kids had been gotten out just in time. Mr. Wilt, who was having a class in my room, said he saw the wall 'weaving' and then the gale died down a little." (Courtesy Westhampton Beach Historical Society.)

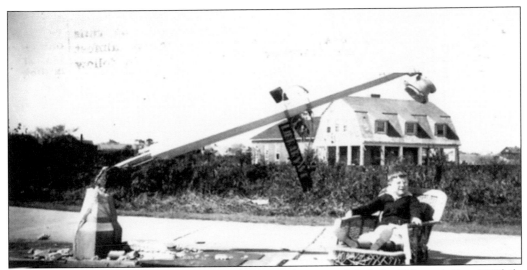

Preston C. Brady, who took this photograph in Westhampton labeled it "Nature's Fury." While the force of the storm's fury did not manage to tear this street lamp from its base, it evidently sent the wicker wreck of a chair on a journey. That it should have landed in this spot, like a living room armchair with its well placed reading lamp, is clearly a source of amusement for this little boy. (Courtesy Southampton Historical Museum.)

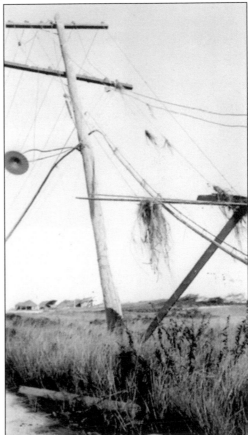

One of the worst temporary results of the storm was the breakdown of all public utilities. Tipped poles like this one, downed wires, and waterlogged equipment presented a daunting challenge to utility crews who struggled to restore service in the aftermath of the storm. Emergency methods were immediately adopted and night crews went to work on an almost hopeless task. (Courtesy Scott Mitchell.)

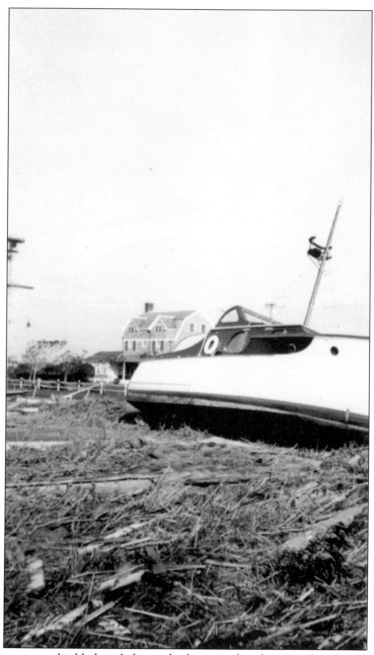

Dozens of boats were disabled and dumped wherever they happened to be when the water receded. Some people risked life and limb to secure their boats. Edward G. Winters swam down the middle of Main Street to get to his 40-foot boat the *Coot*, moored at the Westhampton Yacht Basin. The *Coot* broke loose, traveled up Library Avenue, and finally came to a halt at the Moorland Hotel on Beach Lane. Richard Hendrickson "went down at noon and tied a double rope to the sailboat," his wife Dorothea reported in a letter to her family on September 27. "As it was, the sailboat was lying on its side but still tied to its stake." Meanwhile, Mr. Schaefer's 30-foot pleasure yacht "was washed high and dry up into Mayer's front yard" having "pulled its stake along with it."

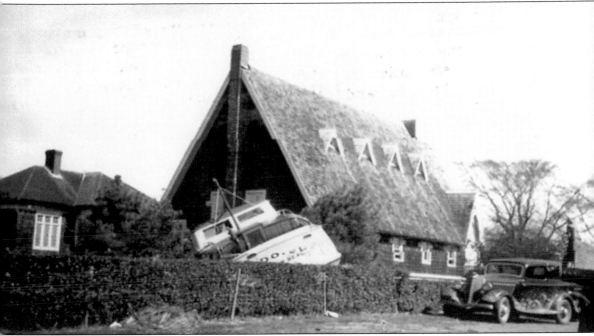

Until the storm hit the Union Chapel on Library Avenue, Dave Potts had been navigating the waters around Main Street in his boat *Dorel*, pulling up to ground-floor windows to find stranded occupants awaiting rescue. A veteran of several Florida hurricanes, Potts had tried to warn others who had mistaken the lull that occurs when the eye of a hurricane is overhead for the end of the storm. His warnings went unheeded. The storm took Gaston Bishop's boat even further, traveling a mile up the creek that leads to Cook's Pond. A very large boat about 60 feet long was stranded high and dry on the Medina estate, while Judge Medina's own boat landed on the Westhampton Beach golf course. The Milbanks' cabin cruiser, which had broken loose from its moorings across Quantuck Bay, arrived at Sandacres, on the western shore of Quogue, where Mimi Eggert Potts Hotchkiss recalled the startled announcement made by the family butler, who shouted, "Madam, there's a boat below!" It had made a quick trip from west to east and come to a halt just outside the living room windows. (Courtesy Scott Mitchell.)

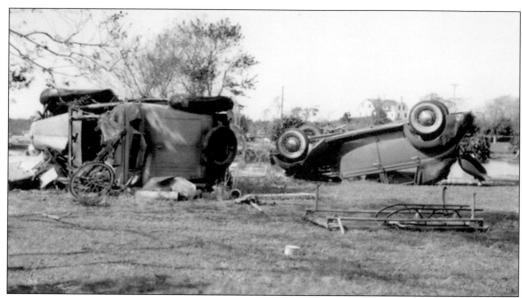

Tossed like toys, automobiles were strewn over the Westhampton landscape. Those that were not ruined were usually no match for hurricane conditions and many is the tale of cars hurriedly abandoned where huge trees blocked the roads or water sucked into the carburetor convinced even the hardiest vehicles to quit on the spot. (Courtesy Scott Mitchell.)

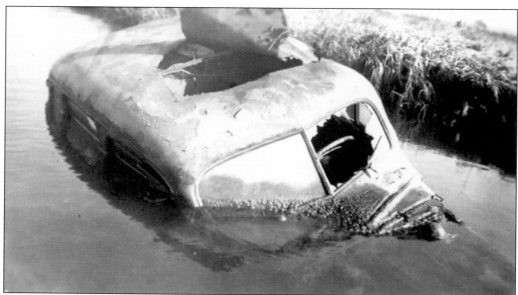

Scott Mitchell retells a story told to him by his grandmother, in whose album this photograph was found. The jagged opening through the roof, was not hurricane damage, rather, it was created by a can opener, she said, presumably to rescue someone trapped in the interior. To be sure, it must have been an industrial-strength version and not the garden-variety kitchen utensil. (Courtesy Scott Mitchell.)

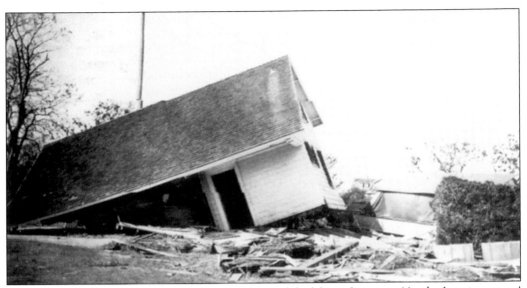

It was not uncommon to see a garage that had been lifted from the ground by the hurricane and put down in somebody else's yard. What happened here in Westhampton—a garage that took off with a car inside—was a little more unusual. (Courtesy Southampton Historical Museum.)

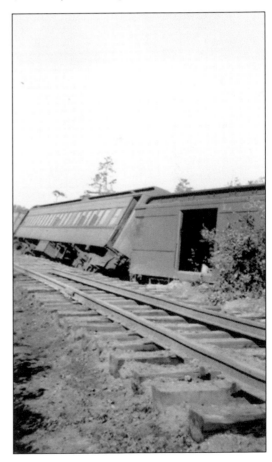

Two Long Island Rail Road trains were derailed by the hurricane near Westhampton. In some places the steel rails were twisted by the force of the wind. Elsewhere the rails were washed out as they were at Napeague between Amagansett and Montauk. Before repairs could be made, buses were pressed into service. (Courtesy Scott Mitchell.)

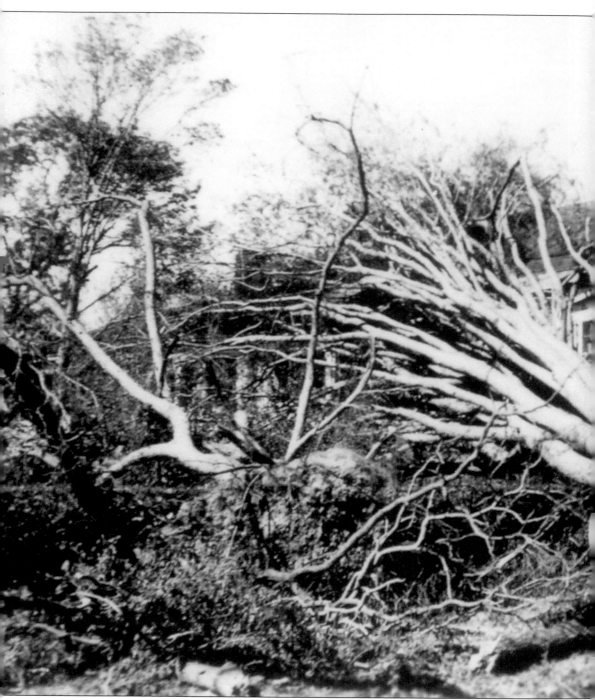

This giant, which crashed to the ground in front of Mrs. William Donnelly's North Main Street house, was thought to be the oldest and biggest tree in Southampton. The estimated weight of its trunk was 10 tons. One account of the damage included this lament: "The scene in many of our streets as night descended, with practically all of our old monarchs lying prostrate and tangled, was one of utter desolation and almost beyond belief." One strange trick performed by the hurricane was to strip the foliage off while leaving the stems attached to the branches,

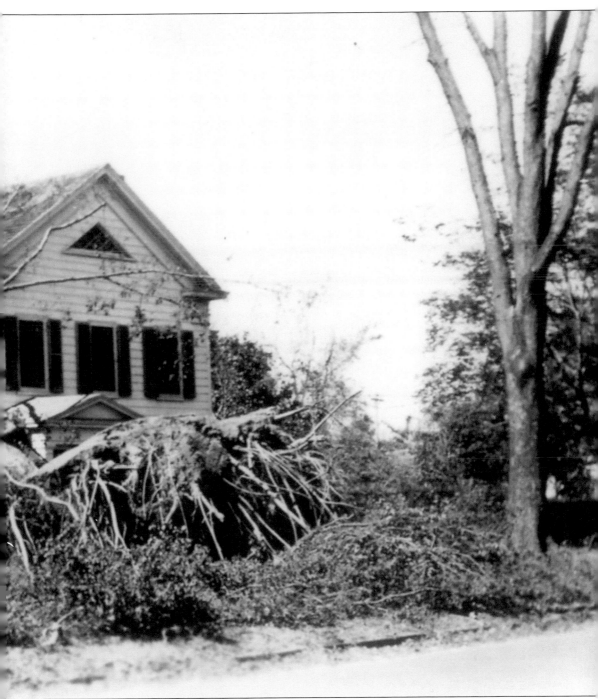

giving a skeletal quality to even those trees that remained standing. Also disorienting was the way that trees seemed to crash to the ground without making a sound, probably because nothing could be heard except the constant, high-pitched scream of the gale. Some people spoke of a phenomenon in which the sound reached such intensity that the mind could no longer absorb it. (Courtesy Southampton Historical Museum.)

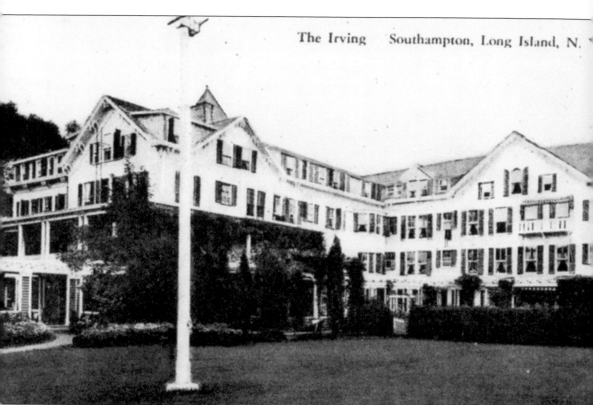

The Irving House Hotel, where Roosevelts, Vanderbilts, Wanamakers, du Ponts, Fords, Bouviers and Kennedys stayed, was the center of the summer social scene in Southampton for many years. In this pre-hurricane view, it proudly commanded its prime location where the estate section and downtown Southampton meet at the corner of Hill Street and First Neck Lane. On the theory that it would be pointless to try to compete with the sumptuous surroundings that wealthy guests enjoyed in their homes, the Irving was simply furnished, the better to make lodgers feel as though they were roughing it out in the country. One longtime Southampton resident who was introduced to the area by a stay at the Irving, described is as "Charming and warm, and intimate and simple, like Southampton itself before World War II." After surviving the hurricane, the Irving continued to dominate the busy crossroads until it was demolished in 1972. (Courtesy Southampton Historical Museum.)

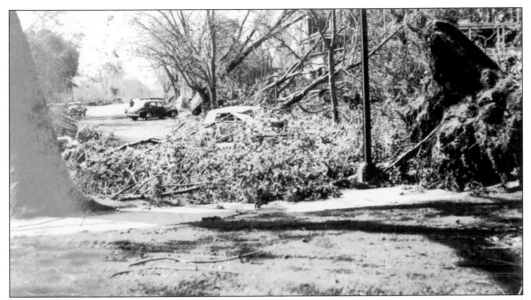

Southampton's haute monde hostelry is barely visible behind this tangle of fallen trees, scattered limbs, and electric wires left by the hurricane. The Irving was not, however, as hard hit as the beach houses of its elegant clientele, some of whom took refuge in it during the storm and remained as hotel guests for the duration of repairs. (Photograph by Richard M. Johnson.)

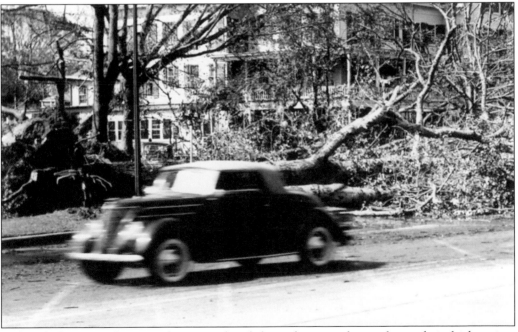

Although the Irving's hurricane losses were largely limited to its gardens and grounds, its high-society gloss had largely dissipated by the 1950s when it became a haven for the rocking-chair set. The hotel's gregarious proprietor could still round up a spirited crowd, however, which he did every year on September 21, when he hosted a hurricane dinner party to which he invited some 50 survivors of the great storm. The annual event ended only with his death in 1952. (Courtesy Southampton Historical Society, Barbara Lord.)

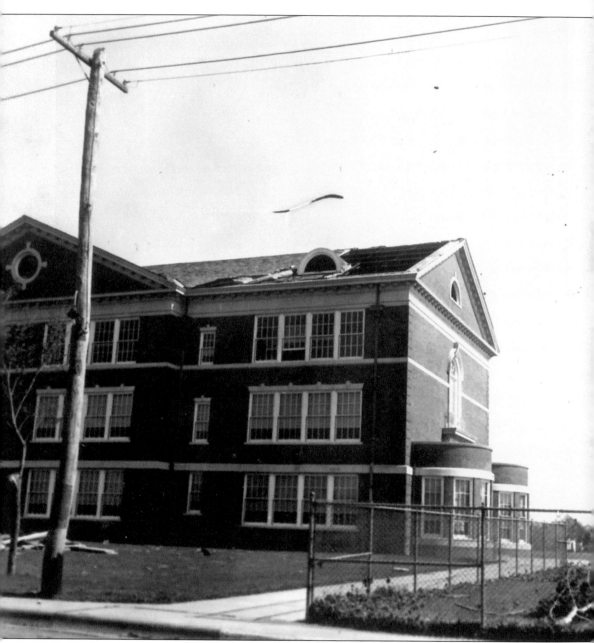

Built of brick with a slate roof, the Southampton Elementary School on Pine Street was brand new in 1938. The bricks stood up to the violent winds, but slabs of slate became dangerous projectiles when they were ripped from atop the school building and hurled through the air. Here one slab appears to have been caught in mid-flight. Years later, a man who was 10 years old in 1938 recalled that the windows of his classroom buckled and broke, and the wind screamed through the corridors. He and the other students were issued football helmets and evacuated to the gymnasium at the high school, which also had a slate roof. All the while, he said, slate slabs were flying through the air, and a high-school student remembered a piece of slate coming through the window of her classroom and slicing in half the chair her teacher had left only moments before. (Courtesy Southampton Historical Museum.)

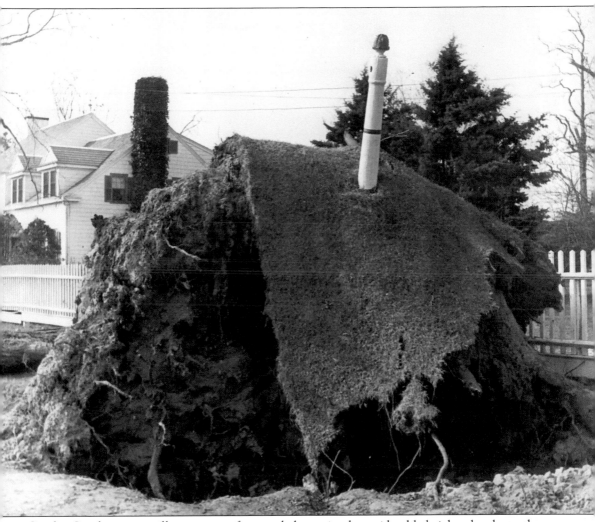

On this Southampton village street, a fence pole has gained considerable height, thanks to the huge mound of earth pushed up by the root system of a sizable tree. For three days before the hurricane, it had rained, saturating the ground so that when the storm struck, even very big trees were easily uprooted. Some saw a bright side in that most trees did not snap but rather folded. Thus they could be winched back, kept upright with guy wires, and saved. Trees that had been in full summer leaf a day earlier were winter-bare, their leaves pasted against buildings or blown away. Barbara Lord recalls watching trees being uprooted from the Southampton movie house lobby. On vacation from boarding school, she and a friend had taken their seat for the Wednesday matinee when the theater's big chandelier began "going backward and forward." Getting out from under it, they went to the lobby, where the manager had locked the door, forbidding them to leave. Eventually, her mother, water soaked and frantic with worry, arrived to reclaim her. (Courtesy Southampton Historical Museum.)

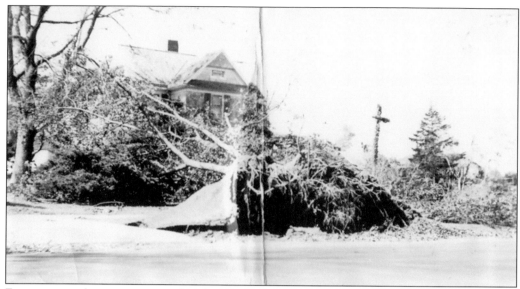

For many people venturing out after the worst was over, the altered landscape of their village was what shocked them the most. Here on Southampton's Elm Street, with so many of its namesake trees felled, the branches of those that survived suddenly winter-bare, and a wide-open sky overhead, it seemed as though the village had lost some essential aspect of its ambiance that it might never regain. (Courtesy Southampton Historical Museum.)

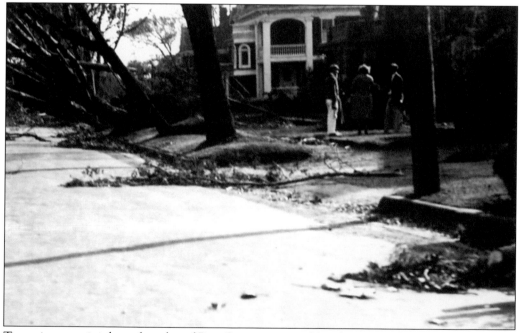

Trees tip precariously at the edge of Post Crossing, one of Southampton's loveliest streets in the heart of the village. Three residents assess the damage, no doubt wondering how to approach the daunting task of putting their street back in order. (Courtesy Southampton Historical Museum, Barbara Lord.)

78

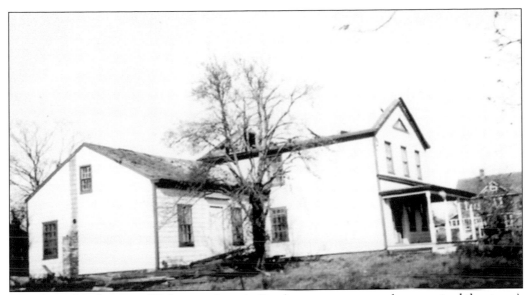

This classic farmhouse on Wickapogue Lane in Southampton appears to have survived the storm's fury unscathed, but a closer look reveals that the main, two-story section is missing its roof. Reroofed and repaired, the house is still standing today. (Photograph Richard M. Johnson.)

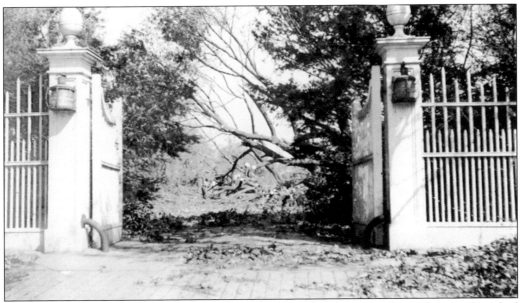

Opposite the Irving House, on Hill Street, the Orchard, the elegant residence that was Stanford White's last project before his murder by showgirl Evelyn Nesbit's jealous husband, lies beyond these handsome gates, which were apparently sturdier than the trees behind them. Originally owned by White's friend and fellow carouser, James Breese, the estate belonged to Charles E. Merrill of Merrill Lynch fame at the time of the hurricane. (Photograph by Richard M. Johnson.)

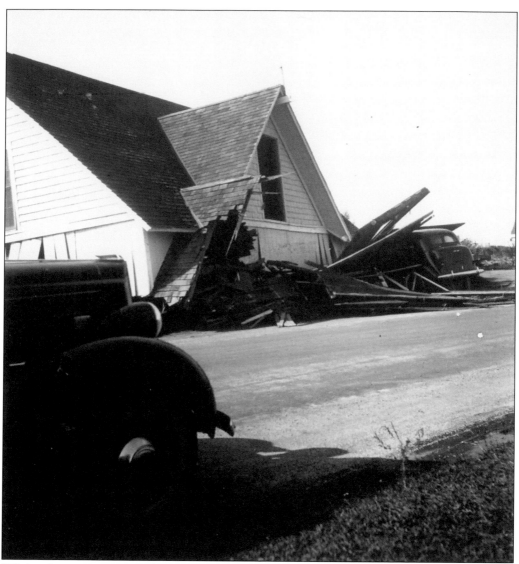

While almost everyone woke up on September 22 to face losses—of trees, shrubbery, and outbuildings—Mrs. Sidney Wood found that she had acquired this errant garage, which landed on her property at the corner of First Neck Lane and Dune Road in Southampton. The worst part of the hurricane, with the stronger and more accelerated winds, came after the hurricane's eye had passed over the shore and moved on toward Connecticut. Many assumed that the storm was over during the temporary lull when the eye was overhead. In a few places, the sun actually made a brief appearance. But then the sky darkened again, rain fell, and the wind suddenly shifted from the east to the south. These second gales, coming in from the ocean with gusts that some estimated at more than 150 miles an hour, pushed ahead of them the towering wall of water that swept away buildings like this one. (Courtesy Southampton Historical Museum.)

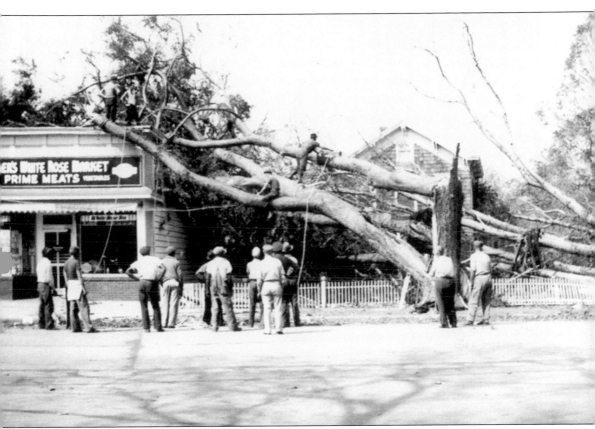

Ernest S. Clowes left a detailed record of life in Bridgehampton in 520 newspaper columns and in a book that is the standard reference on the 1938 hurricane in the Hamptons. His account of September 21 begins by noting that life was going along "altogether as usual" under a sky in which the sun shone intermittently "with a watery glare in which was a hint of green." The drama builds gradually, with heavy rain reported a little after 1:00 p.m., and winds reaching 45 miles an hour by 2:00 p.m. By 3:30 "at Bridgehampton . . . with the wind up to 75 miles an hour, trees were going down all over the place, and along the ocean beaches the sea was rising fast, for this great gale was literally gathering up the rising tide and hurling it bodily toward the land." At about 4:30 p.m., the wind lessened as the eye passed, and the sky brightened and some people saw the sun. Then the wind shifted through south to southwest and became stronger than ever. By 5:30 p.m., the hurricane was over. Among the trees that were uprooted was this one, which appears to have dented the roof of Muller's White Rose Market, on Main Street. (Courtesy Bridge Hampton Historical Society.)

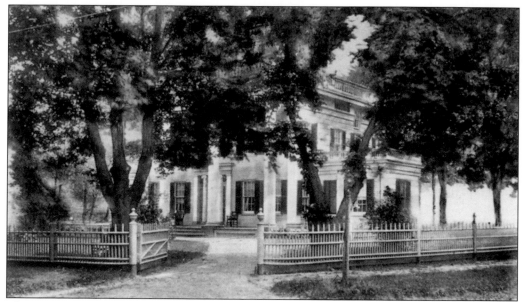

The Hampton House, a Bridgehampton landmark widely admired as a rare and exquisite example of Greek Revival architecture, was once the home of Nathaniel Rogers, a miniature portrait painter who painted "most of the fashionables" of New York City society. Later, at the time of this image, it was a favored hostelry among those same "fashionables." In 2003, the deteriorated building was acquired by the Town of Southampton and a restoration campaign was launched by its stewards at the Bridge Hampton Historical Society. (Courtesy Southampton Historical Museum.)

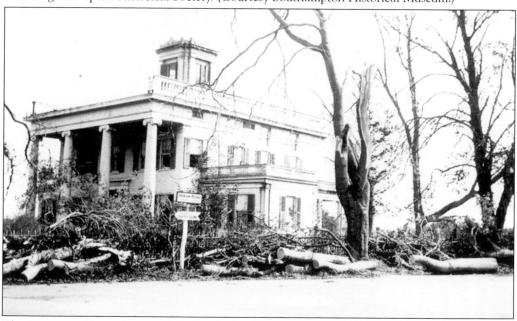

The Hampton House (now called the Nathaniel Rogers House) did not escape damage during the hurricane. It lost part of its roof balustrade, as this photograph attests (although not its cupola, despite reports to the contrary). After repairs, Caroline Augusta Hopping continued to operate it as an inn until as late as 1948, after which it remained in the Hopping family until its purchase by the town. (Courtesy Bridge Hampton Historical Society.)

Along Bridgehampton's Main Street, the monument and the liberty pole "stood unhurt though the old gilded eagle from the pole had flown away to alight only slightly damaged," Ernest S. Clowes noted. Amid the devastation, other cheering notes included the sight of the Bridgehampton Presbyterian Church, still standing at mid-Main Street after 95 years, along with "nearly all its surrounding trees" and its clock still running. (Courtesy Southampton Historical Museum.)

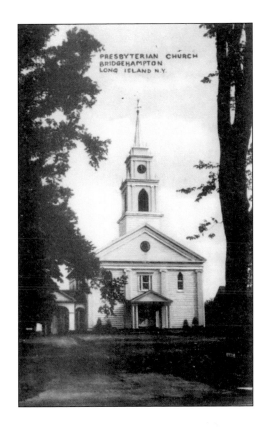

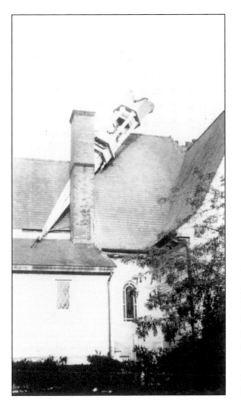

While the Presbyterian church got a pass from the hurricane, the Catholic church was not so lucky. Shot like an arrow by the force of the wind, its steeple plunged into the church roof. Down the road, the belfry and steeple of the Methodist Church lay in the yard, "a tangled mass of wreckage," wrote Ernest S. Clowes. Many churches throughout the Hamptons suffered similar fates. (Courtesy Southampton Historical Museum.)

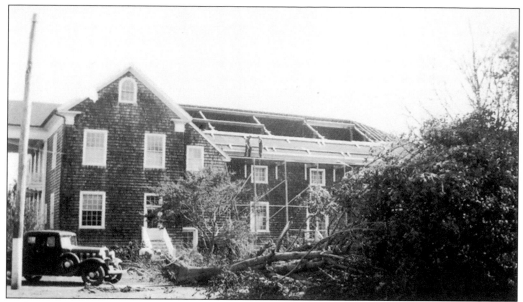

Making his post-hurricane rounds, Ernest S. Clowes was dismayed to find "nearly all the west roof of the Community House [pictured on September 25] lay in the yard amid the wreckage of more than half the trees." Lumber Lane, the Sag Harbor Turnpike, Ocean Road, School Street, and many other streets were "quite impassable for wheeled traffic and difficult for people on foot for they were just a jungle of trees, branches, and fallen wires." (Courtesy Bridge Hampton Historical Society.)

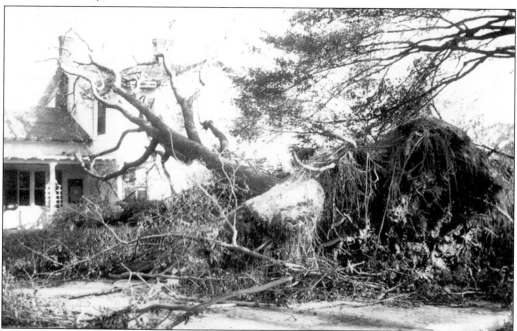

At the Bridgehampton library, a huge tree went down, one of some 750 felled trees counted in Bridgehampton and outlying districts a few days after the storm. Ernest S. Clowes remarked on the "curious effect" the fallen trees had on the streets, where "people seemed to be burrowing through a jungle of green that rose as high as 20 feet." (Courtesy Bridge Hampton Historical Society.)

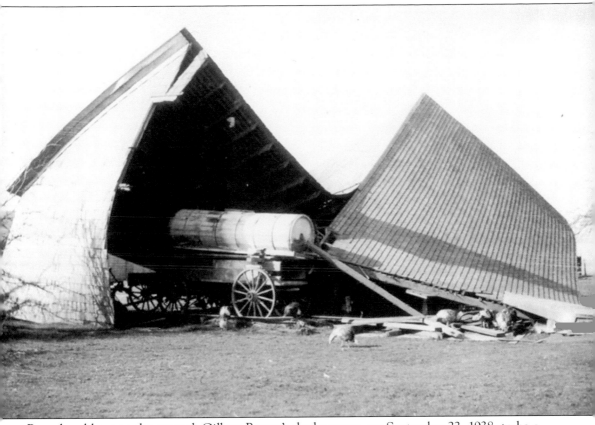

Bowed and bent to the ground, Gilbert Rogers's shed appears, on September 22, 1938, to be a total loss. The cart parked inside and the tank atop it, however, seem miraculously undisturbed. In Bridgehampton, the lowest recorded barometer, according to Ernest S. Clowes, was 28.40 inches, reached between 4:00 and 4:30 p.m. The eye passed over around 4:30, and the wind lessened to 50 miles an hour before returning to hurricane force. When it finally subsided, the storm left "a changed scene, a new landscape," wrote Clowes, "for where that morning great avenues of trees had stood in the full leaf of summer there were great gaps in the sky, and all the trees that stood were as bare and barren as in late November." (Courtesy Bridge Hampton Historical Society.)

This view of A. P. Rogers's house on Sagg's Main Street taken on September 22, 1938, shows that the house, and even the fence have weathered the storm. Despite the loss of the huge tree that has gone down in the yard, there was much for the family to be thankful for when so many others awoke that morning in houses with windows broken, chimneys down, roofs smashed in or taken off, and tree trunks blockading the premises. In her letter of September 27, Dorothea Hendrickson gave this description of post-hurricane Bridgehampton: "Thursday we did a little driving around. The wrecked houses, barns, churches, and the trees down are a pathetic sight. The Coast Guard at Bridge Hampton told us that he was in his house with his wife and three small children at the time of the storm. The house is about 200 feet from the ocean beach. The waves broke over his house (30 feet high) and washed the house loose. Ten more minutes and they would have washed out to sea. But fortunately the water receded and the wind changed. What an experience!" (Courtesy Bridge Hampton Historical Society.)

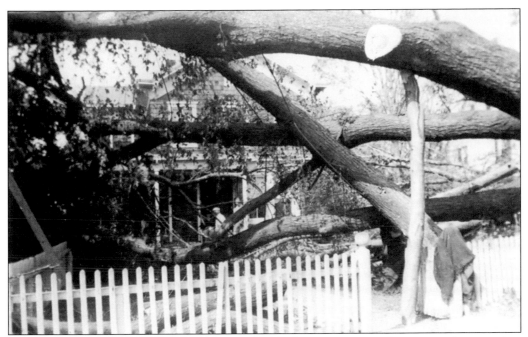

Removing gigantic trees that lay prostrate after the hurricane was a daunting task—one that Conrad Schenck faced in the immediate aftermath of the storm when this photograph was taken. For him, simply negotiating his way from the front door to the front gate was a challenge, although the challenge did not end there since roadways, too, were choked with trees, branches, and fallen wires. (Courtesy Bridge Hampton Historical Society.)

Thankful for an undamaged lawn chair and a return of pleasant weather after the hurricane, Conrad Schenck seems to be counting his blessings rather than cursing the fates that have created the mess in his yard. Working with hand saws, homeowners and their helpers faced many hours of hard labor, from which the occasional break was more than justified. (Courtesy Bridge Hampton Historical Society.)

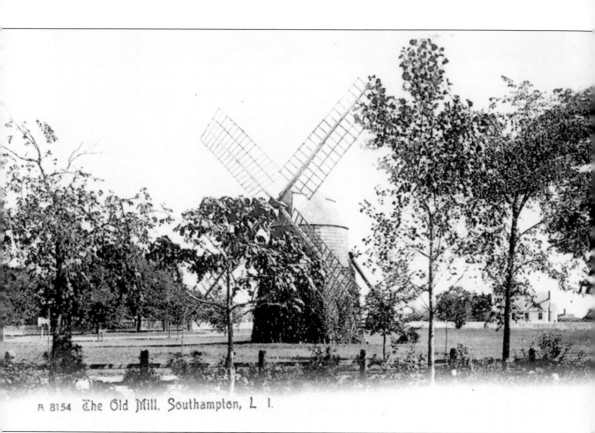

A 8154 The Old Mill, Southampton, L. I.

The Corwith windmill has been a familiar landmark on the picturesque Village Green in Water Mill within the borders of Southampton town for longer than anyone can remember. It is the smallest, and second oldest of 11 surviving windmills on the South Fork of Long Island, which has the largest regional group of windmills in America. Originally built around 1800 in North Haven (then known as Hog's Neck), it is believed to have been purchased for $750 by James Corwith in 1813 and moved to its present site. In a history of the hamlet compiled by members of the community, it is speculated that James Corwith probably had the mill disassembled and its parts moved by teams of oxen to the Water Mill Commons, where it replaced a windmill that had been destroyed in the Christmas storm of 1811. The Corwith windmill ceased to grind in 1887 but remained an important and very visible landmark. In 1934, the mill and the "common ground" became the property of the Water Mill Village Improvement Association. When, in the wake of the terrible 1938 storm, it was left with its top all but severed, cosmetic repairs were made, but it was not until 1987 that the community rallied to fully restore the mill, making it a working gristmill once more. (Courtesy Southampton Historical Society.)

In its edition of October 16, 1938, the *New York Herald Tribune* printed the following caption beneath a photograph showing the Corwith windmill in its sad, semi-decapitated state: "A historic landmark suffers—the disused windmill (c. 1800) on the village green at Water Mill, Long Island, its upper structure now reduced to a litter of planking and shingles." (Photograph by Richard M. Johnson.)

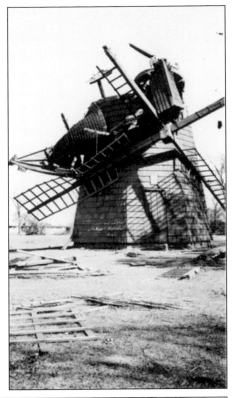

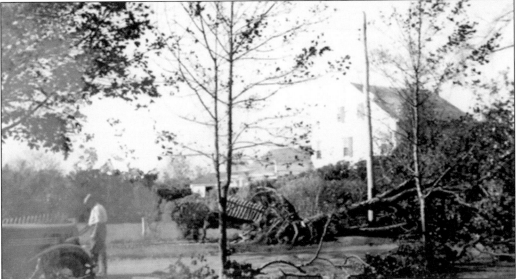

This Water Mill property, a stone's throw from the village green in Water Mill, presents a typical scene of post-hurricane mayhem. The southern section of Water Mill, with its many creeks and coves extending inland from Mecox Bay, was particularly flood-prone, something Dorothea Hendrickson discovered when she set out on the evening of September 21 to drive home to Bridgehampton from her job in Southampton. At the Mecox Duck Farm, she found Montauk Highway "under water for a quarter mile with ducks and debris floating around." (Photograph by Richard M. Johnson.)

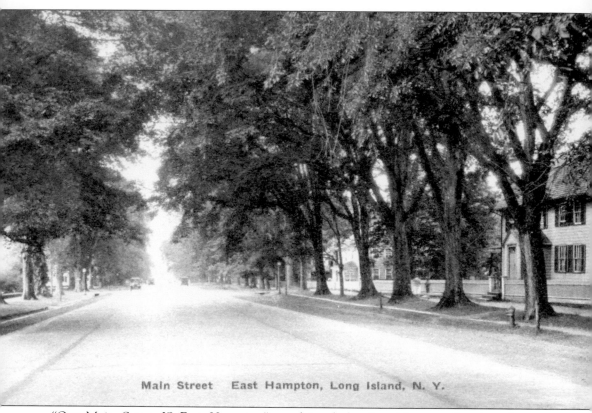

Main Street    East Hampton, Long Island, N. Y.

"Our Main Street IS East Hampton," proclaimed the *East Hampton Star* in a hurricane post-mortem. And what made Main Street the emblem and essence of the village were the noble giants that flanked it—the elms that spread their canopy overhead and sweetly shaded the passage below. Although East Hampton did not suffer as badly as Southampton or Westhampton along the coast, much damage was done when the ocean joined Georgica Pond, Lily Pond, and Hook Pond, flooding homes and overrunning bathing beaches. Cabanas at the Maidstone Club were lost and a portion of the golf course destroyed. Those could all be repaired, but the loss of almost half of Main Street's beautiful elms was a devastating blow from which it seemed to many that East Hampton might never recover. Then came the rallying cry: "Main Street to Rise Again!" announced the *East Hampton Star*, which used its pages to deliver three messages to anguished residents: stumps were not to be hastily uprooted since some would likely put out buds in the spring; picket fences, also crucial contributors to East Hampton's charm, should be repaired rather than scrapped; and anyone who knew where to get replacement elms should alert someone on the LVIS Tree Committee to their availability. The latter request came with a caveat, however: trees "from away" were not wanted as eastern Long Island had remained free of the Dutch elm disease prevalent in other localities. (Courtesy Eric Woodward collection.)

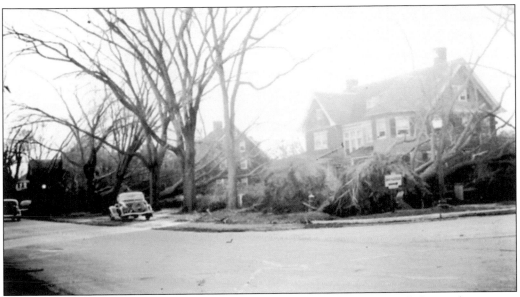

"The sun rose this morning on the saddest sight East Hampton has ever seen," observed a reporter for the *East Hampton Star* on the day after the hurricane tore through the village. "It seemed at first glance," he continued, "that hardly a tree was left on Main Street." This crossroads, where East Hampton's Main Street and the road to Sag Harbor meet, was typical, with its grim view of felled giants. (Photograph by Richard M. Johnson.)

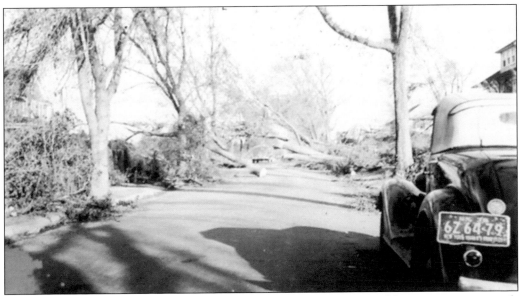

Some trees were spared, some knocked askew and some were uprooted bringing great mounds of earth to the surface. This view of Dunemere Lane in East Hampton brings to mind Ernest S. Clowes's description of the "curious effect" the many fallen trees had on streets where "people seemed to be burrowing through a jungle of green that rose as high as 20 feet." (Photograph by Richard M. Johnson.)

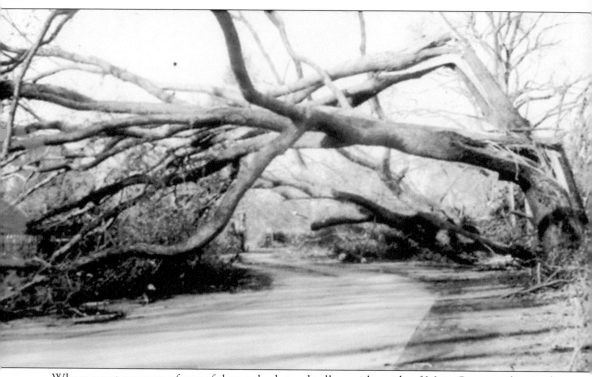

Where great avenues of graceful trees had stood tall on either side of Main Street earlier in the day, a hodgepodge of huge, leaning tree trunks and broken branches remained after the hurricane tore through East Hampton. Instead of passing under the leafy canopy that had shaded passersby just hours earlier, people taking this route after the storm walked under graceless arches formed by bent, broken trunks. In part, the winds that ripped these towering trees with their huge root systems right out of the ground were helped in their destructive task by the days of rain that had preceded the storm, saturating and softening the ground. However, as Marc de Villiers observed in his book, *Windswept*, even without aggravating circumstances, hurricane winds are capable of exerting almost unimaginable force. He noted that, in 1935, when a hurricane that today would be classified as a category 5 hit the Florida Keys, it sandblasted some of its victims into particles, leaving only bones, leather belts, and shoes. In one day, as he noted, a moderate hurricane releases the energy equivalent of 400, 20-megaton nuclear bombs: enough, if converted to electricity, to power New England for a decade. (Photograph by Richard M. Johnson.)

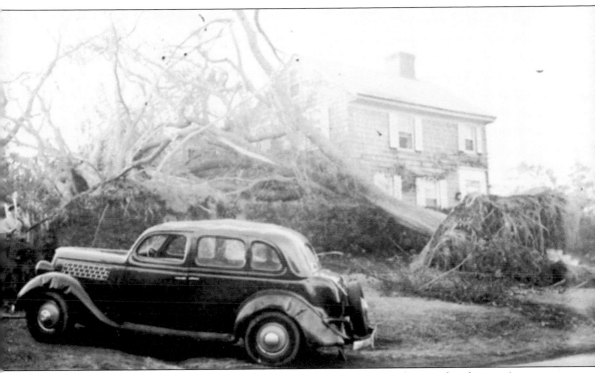

The hurricane took a heavy toll on the Main Street, East Hampton, home of architect Aymar Embury II, designer of two of the village's most prominent landmarks: the cultural center Guild Hall and the East Hampton Free Library. Several massive trees went down on the property, a particularly disheartening loss for Embury's wife Ruth Dean a renowned landscape architect. Embury, a mainstay of the East Hampton cultural community, helped shape New York City's landscape, although few today are aware of his contributions. He supervised the design of the Whitestone, Triborough, Henry Hudson, and Marine Parkway Bridges. He planned the Central Park Zoo, Orchard Beach, and swimming pools and parks. He served as chief architect for Robert Moses and guided the work done by federal Works Progress Administration (WPA) workers, as the city began its climb out of the Depression. A 1940 exhibition at Guild Hall paid tribute to Embury, with a display of many of his drawings for the bridges and other projects. (Photograph by Richard M. Johnson.)

OSBORNE HOUSE, East Hampton, L. I.

The Osborne (Osborn) House, now the Maidstone Arms Inn, has held its commanding site at the entrance to East Hampton, overlooking the old burial ground and the village green, for more than 150 years. Originally the site of the Osborn tannery, established by Thomas Osborn upon his arrival from New Haven in 1660, it remained in the family until 1924, when the Hampton Hotels Corporation added dormers and a porch and converted it into an inn. A flat-topped knoll in front of the inn on the village green was created so that the 1771 mill could better catch the breezes, according to *East Hampton: A History and Guide*, by Jason Epstein and Elizabeth Barlow. The mound was later moved to the property of Home Sweet Home. The inn suffered considerable damage in the 1938 hurricane but survived. Completely renovated in 1992, it continues to reign as a handsome village landmark, as well as a popular gathering place. (Courtesy Eric Woodward collection.)

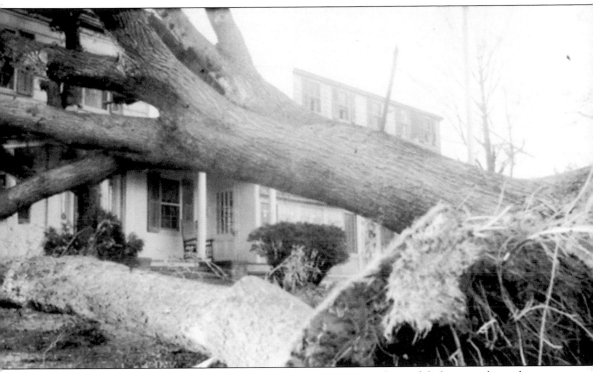

The *East Hampton Star* reported that "One of Main Street's most beautiful elms was lost when this one crashed against the Maidstone Arms, causing damage to the roof, second floor and front porch." Other Main Street landmarks fared better, as the *East Hampton Star* noted: "East Hampton's beloved 'Home Sweet Home' came through the storm practically unharmed; also its twin, the 17th century John Henry Mulford house next door." Guild Hall, the East Hampton Free Library, and the Clinton Academy had only minor damage. The Presbyterian Session House lost its cupola, and St. Philomena's Roman Catholic Church (now Most Holy Trinity) lost its steeple. The Barns Building, on Newtown Lane, which housed the post office on the ground floor and town offices above, was badly damaged when it broke the fall of a very big tree. Movie patrons displayed behavior that was "very orderly in view of the circumstances," according to the *East Hampton Star*. After collecting their refunds at the box office, they were assisted by police in crossing the street, at some risk, since "the letters on the theatre signs were beginning to drop" and the trees "were swaying madly, threatening to fall any moment." (Photograph by Richard M. Johnson.)

Architect Aymar Embury II submitted three facade alternatives in 1911 for East Hampton's new library to be built on land donated by the village's great patrons, Mr. and Mrs. Lorenzo E. Woodhouse. One was in a Beaux-Arts-Georgian-style facade, a second design was a more chaste Adamesque colonial, and the third, the one chosen and shown above, was in an Elizabethan vernacular–style facade. (Courtesy Eric Woodward collection.)

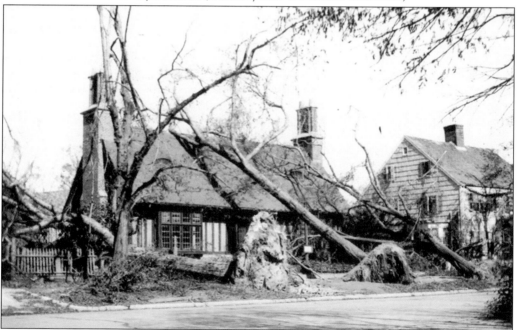

Fortunately the library was neither crushed nor even severely damaged when three giant trees were uprooted just yards from the front door. The *East Hampton Star* reported that the wreckage was soon cleared away and it was "business as usual" on the day after the disaster. (Courtesy Bridge Hampton Historical Society.)

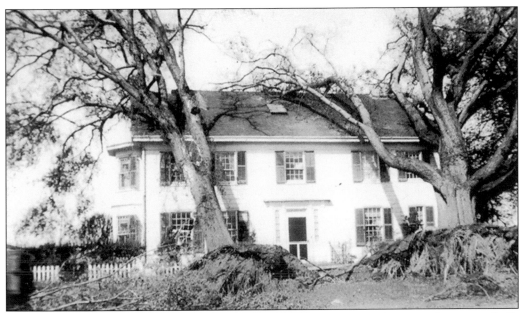

The home of Mrs. Norman Barnes (née Huntting) lost its two sentinel trees in the storm. Built on North Main Street around 1835 by Abraham Huntting, it had once housed a general store run by Abraham's two sons, James Madison and Otis. There were alterations over the years, one of which removed the wing the brothers had used for their store. (Courtesy Sherrill Foster.)

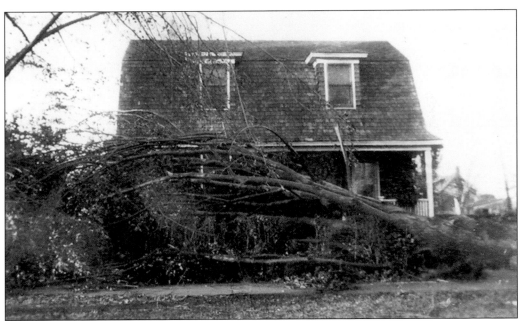

At Newtown Lane and Gould Street (formerly Hicks Street) the Parsons house was behind a barricade of branches after the hurricane. No street was spared as the storm ripped trees from the earth, then threw them back down to the ground. Amidst the devastation, the good news was that East Hampton's historic windmills sustained only minor injuries that could be easily repaired. (Courtesy Sherrill Foster.)

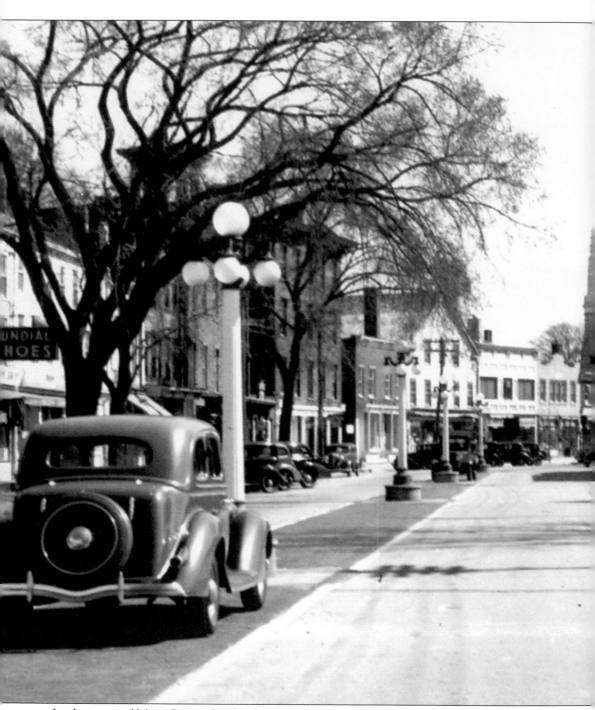

In this view of Main Street, Sag Harbor, which was taken by Andrew M. White on April 10, 1938, the steeple of the Old Whaler's Church (Presbyterian) rises to a commanding height over the village's bustling downtown. Such was its charm that in 1932 Sag Harbor's Main Street was chosen by Paramount Studios as the perfect place to take street scenes for their upcoming film, *No Man of Her Own*, starring Clark Gable and Carole Lombard. Among other films of the era that took advantage of Sag Harbor's picturesque settings, were *Major Charles Gordon*,

*MD*, starring North Haven summer resident William Farnum with Mary Martin as his leading lady, and, five years later, *Back Home and Broke*, which used Sag Harbor for all exterior shots. A parade scene in the latter was filmed on Main Street and used 40 local people in small parts and familiar landmarks like Fahys watch case factory, the Masonic temple, Woodward Brothers Grocery, William Cook's Department Store, and the bank as backdrops. (Courtesy First Presbyterian Church of Sag Harbor.)

With its steeple shaped like a sailor's spyglass and rising to a height of 185 feet, (making it the tallest structure on eastern Long Island), the Old Whaler's (First Presbyterian) Church of Sag Harbor was a welcome sight to whalers returning to port at the end of their long voyages. Built in 1843–1844, when Sag Harbor was a prosperous whaling center, the church was designed by Minard Lafever, a leading architect of the time who incorporated some unique maritime motifs into his Egyptian Revival design. (Courtesy Eric Woodward collection.)

A witness to the church spire's demise described how the wind entered through louvers during the hurricane, lifted the steeple straight up in the air, then dropped it in front of the church. The message the Reverend Donald Crawford, church pastor from 1940 to 1950, took from the loss must have irritated bereft parishioners. The shattering of the steeple was "no accident," he told them. They had reached a point where "they were worshipping the steeple more than they did God," he scolded. "So He took it away." (Courtesy Sherrill Foster.)

# *Three*

# RUBBERNECKING AND REBUILDING

"Death by the hurricane, most grim of reapers, took a heavy toll in Westhampton Beach when 29 people lost their lives," so began the account in the *Hampton Chronicle* edition of September 30, 1938. Corpses, the correspondent went on, were laid out in a makeshift morgue set up at the country club, where "flashlights and candles gave an even more eerie atmosphere to the already gruesome scene as distraught relatives came in to identify bodies."

Thursday was indeed a dark day in Westhampton as families sought news of missing loved ones, always fearful of finding them among the dead. With the breakdown of electricity, transportation, and communications, the threat of looting and lawlessness added to residents' distress and National Guardsmen, along with state troopers, ringed the village as planes flew all day overhead.

In Southampton, night crews were out before dawn on Thursday, working to restore electric power, which had failed completely. And everywhere, trees leaning precariously over roadways, tangled wires underfoot and debris-filled streets did nothing to discourage rubberneckers who began appearing on the streets as soon as the clouds thinned and the rain turned to drizzle. Ernest S. Clowes described bands of them going about "with awe-struck faces, looking for companionship, comparing stories, seeking friends, even laughing a little with that irrepressible American reaction of hysterical gayety toward stunning loss."

After that, it was the sound of hand saws that perpetually filled the air as the massive cleanup got under way.

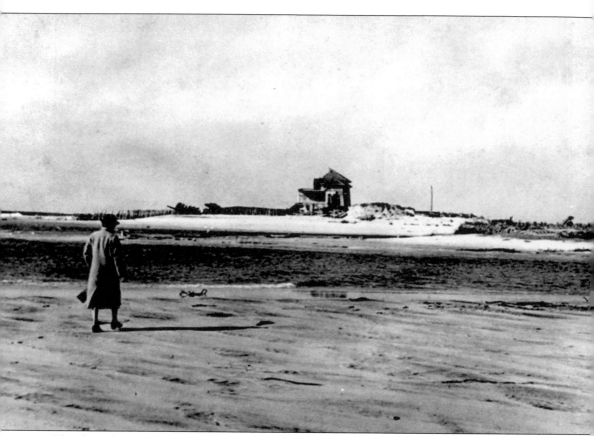

The first place people headed as soon as some calm was restored was the beach. What this Westhampton Beach woman found was an awesome expanse of water and empty sand. Once the site of three or four houses before this inlet broke through, the beach here had been swept clean by waves that carried the debris inland. In his hurricane reminiscence, Lee Davis offered this description of his impressions as he took a dazed look at the damage: "It would be months before the village would begin to return to normal. The beach was the oddest sight of all. It was as if a giant, cosmic hand had come along and with one swift motion, swept it clean of dunes and homes. Where once huge bathing clubs and giant summer palaces had stood on two-story dunes rich with grass, there was nothing but a flat vista of sand, beyond which a placid, shimmering ocean broke, calm and inviting." (Courtesy Westhampton Beach Historical Society.)

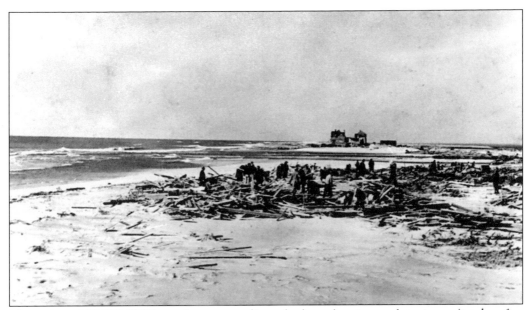

More than 100,000 WPA workers were dispatched on hurricane duty immediately after the storm. Their efforts were combined with those of other federal units and the Red Cross throughout Long Island and the New England coast. Here, looking west on the beach near the West Bay Bridge (Swordfish Bridge) in Westhampton Beach, WPA men conduct a sad search of the wreckage. (Courtesy Westhampton Beach Historical Society.)

What no searcher really wanted to find was another hurricane victim like this one. Sadly there were many to be found in Westhampton Beach, where the Patio Building on Main Street became emergency headquarters and the Westhampton Country Club was used as a temporary morgue and hospital. Lee Davis, the son of a doctor, remembers his father tending the wounded there, who along with the dead, numbered 200 "from a town whose population was under a thousand." (Courtesy Westhampton Beach Historical Society.)

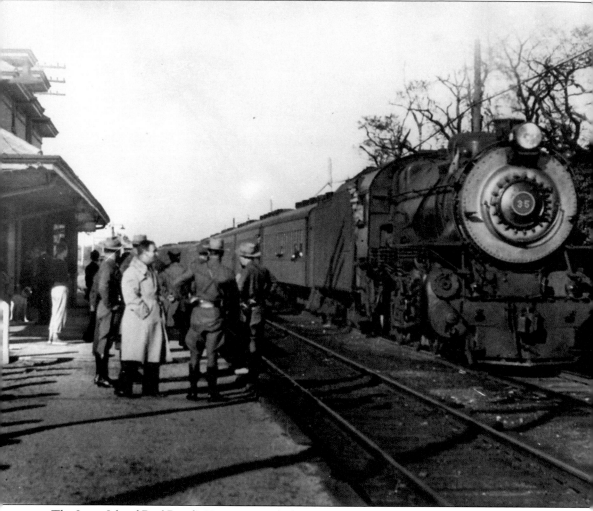

The Long Island Rail Road's Hurricane Relief Train brought WPA workers and others to the East End on a daily basis during the post-hurricane emergency. Writing to her mother on September 23, schoolteacher Miriam Harmon reported that Westhampton Beach was "still under martial law, but there aren't quite so many airplanes, or so low, or quite so many WPA workers around." Approximately 1,300 WPA workers were assigned to the South Shore of Long Island, about half of them from Nassau County. Reconstruction of the dunes was considered urgent. If it did not begin immediately, warned superintendent of highways Hermon F. Bishop, winter storms could easily do more damage, reducing many miles of shoreline to a barren waste. Although there was some grumbling about importing workers rather than using local labor, Bishop argued that, with residents prostrated by their own losses, state and federal funds would be needed to replace or repair public property. Those funds would go mostly for labor, making the reconstruction a valid WPA project. Timbers for building the needed jetties and bulkheads could be salvaged by workers from the 50 square miles of forests blown down by the hurricane winds. The task of clearing forests was also urgent, he warned, in order to reduce the risk of fire. (Courtesy Ron Ziel collection, Queens Borough Public Library.)

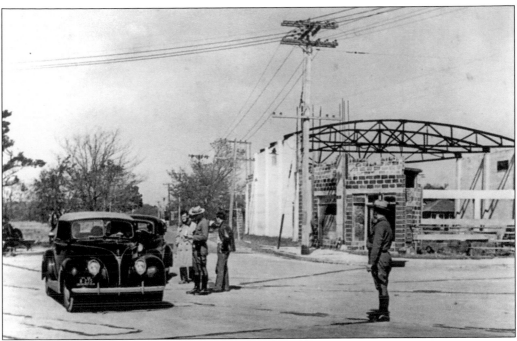

In this photograph, looking north up Oak Street at Six Corners in Westhampton Beach, state troopers are seen checking a driver seeking passage. This was the only entry to the village right after the hurricane; all others were barricaded by deputies and no one without a good reason for being there was allowed in. (Courtesy Westhampton Beach Historical Society.)

Nº 1661   **VILLAGE WESTHAMPTON BEACH**

Permit ..Demarest.Rogers......................... to pass to and from and about the Village except areas closed, unless he or she is an actual resident of said area.

Any restricted area - Dunes included

Dated Sept. .....Sept..27., 1938.

...........................................................

**Chief of Police of Village of Westhampton Beach.**

Demerest Rogers, owner of the Rogers Beach Club, or Rogers Pavilion, which was badly damaged in the hurricane, could have had no trouble convincing those manning the Six Corners checkpoint that he had important business in the village. Permits like this one issued to him on September 27, 1938, by chief of police Stanley J. Teller were required for passage. (Courtesy Westhampton Beach Historical Society.)

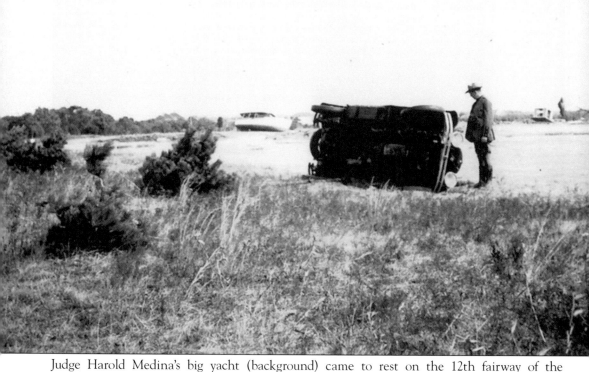

Judge Harold Medina's big yacht (background) came to rest on the 12th fairway of the Westhampton Country Club. Meanwhile, a car dumped on its side has caught the eye of a state trooper. In his reminiscence in the Westhampton Beach and Quogue Historical Societies' publication *The 1938 Hurricane As We Remember It*, Stuart P. Howell Jr. spoke of wandering over to the country club the day after the hurricane. "There was furniture, wood, all kinds of debris, even boats, all over the golf course. . . . Men were searching under the rubble for bodies. During the day, police and national guard troops were positioned on all roads into the village to keep out looters and sightseers." For a boy the day was exciting, especially when a single-engine airplane landed in Bishop's Field across from his home, bringing a news reporter to the scene. "That was kind of thrilling," he said, "because in those days, seeing an airplane up close was a rarity, even though there was a private airfield about three miles north of the village on the road to Riverhead." (Courtesy Marion Van Tassel.)

Although Coast Guard stations at Westhampton Beach and Moriches were demolished by the hurricane, groups like this one were on the job working night and day at the task of rescue. A crew of 50 men from New York arrived with four power boats, and other crews from throughout Long Island were speeded to the scene of the disaster. (Courtesy Westhampton Beach Historical Society.)

The hurricane played havoc with the bridges that link the barrier beach to the mainland and span the many creeks and coves in and around Westhampton. Even those that were not ripped apart and made useless, as was the West Bay Bridge, had taken a beating so that this crew of bridge examiners, sent out to assess the damage and make recommendations, had their work cut out for them. (Courtesy Marion Van Tassel.)

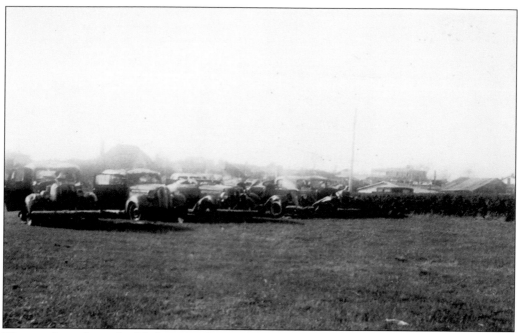

The number of cars disabled on the dunes and in parts of Westhampton Beach within half a mile of the bay shore was in the dozens. The cars above have been retrieved and lined up ready to be dumped into the water once again as fill for one of the new, unwanted inlets. (Courtesy Marion Van Tassel.)

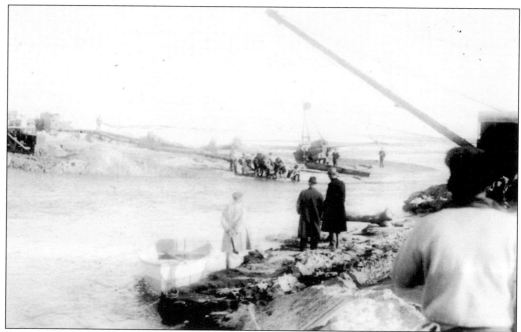

Onlookers watched with fascination as workmen set about filling an inlet with wreckage. Dune reconstruction and other tasks associated with restoring the shorefront, which was left more vulnerable than ever to future winter storms, were the costliest and most urgent post-hurricane activities. (Courtesy Marion Van Tassel.)

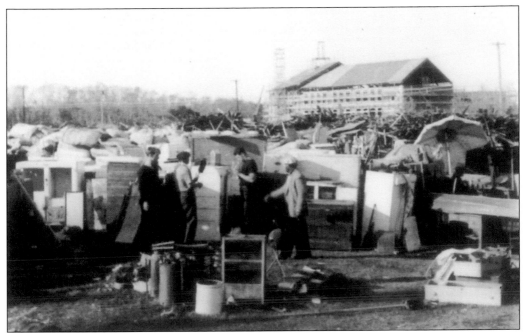

Police and WPA workers brought items worth salvaging to a field across from what is now the Westhampton Beach middle school (then under construction as a high school). Called the Salvage Depot, it was the place where people could come and reclaim their property. (Courtesy Westhampton Beach Historical Society.)

Like other downtown shops, Schwartz's Department Store was flooded when a wall of ocean water pushed by the storm surge reached a height of six feet on Main Street. While Schwartz's survived and resumed serving its customers in Westhampton Beach after the hurricane, getting back to normal took time and considerable infusions of cash. (Courtesy Westhampton Beach Historical Society.)

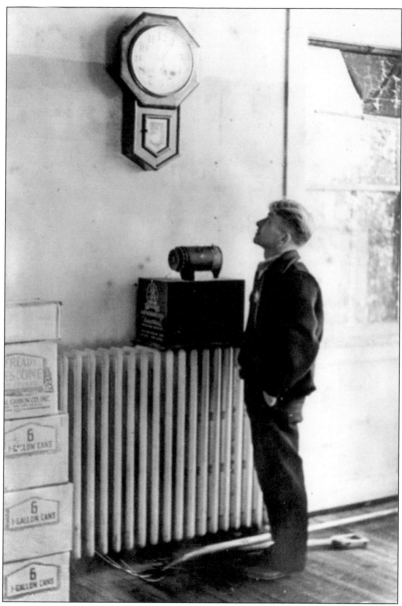

Pete Michne contemplates the high water mark (at about 9 on the clock) in Raynor's Garage on Library Avenue in Westhampton Beach. Although a storm surge is not technically a tidal wave, which can only be caused by an earthquake, it is no less dangerous or frightening. Most of the surge is due to wind, which causes the water to pile up. In the open ocean, the water can flow away under the storm. But as the hurricane nears land, the water cannot flow away readily, so it piles up, and often quite suddenly, as it did in Westhampton Beach. To anyone who did not experience it, the swiftness of its arrival is hard to imagine. For those who lived through it, the memory of its rapid progress remains terrifyingly vivid. Survivors described their nightmarish terror much as Lee Davis did in his reminiscence of his last glance before fleeing: "And it was then and there," he observed, "at that moment, that I saw that green wall of water advancing across the fields behind our house, chasing its stumbling refugees, beyond the protecting glass of my bedroom window." (Courtesy Westhampton Beach Historical Society.)

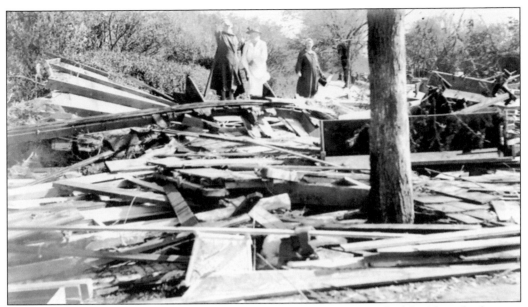

Sightseers were saddened to find that the last remaining bath houses, which had been built many years earlier for Southampton's public "bathing station" on the ocean opposite Lake Agawam, had been utterly destroyed by the hurricane. In its glory days, the public bathing facility boasted 230 separate bath houses and a contemporary brochure welcomed bathers to "take a dip in the ocean or Lake Agawam from the same bath houses." (Photograph by Richard M. Johnson.)

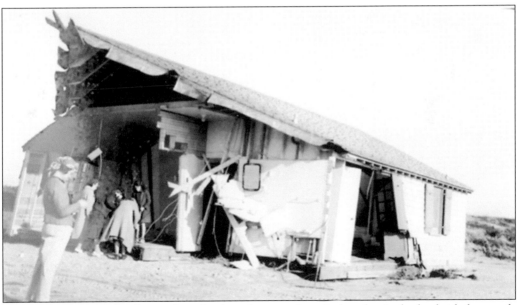

Discretion was mostly observed in the breach once the wind and rain had subsided enough to allow people to venture out and look around. Here some who might ordinarily have been paragons of discretion—perhaps giddy with relief after hours of terror—show little restraint in snooping around the remains of a beach cottage on Dune Road in Southampton. (Photograph by Richard M. Johnson.)

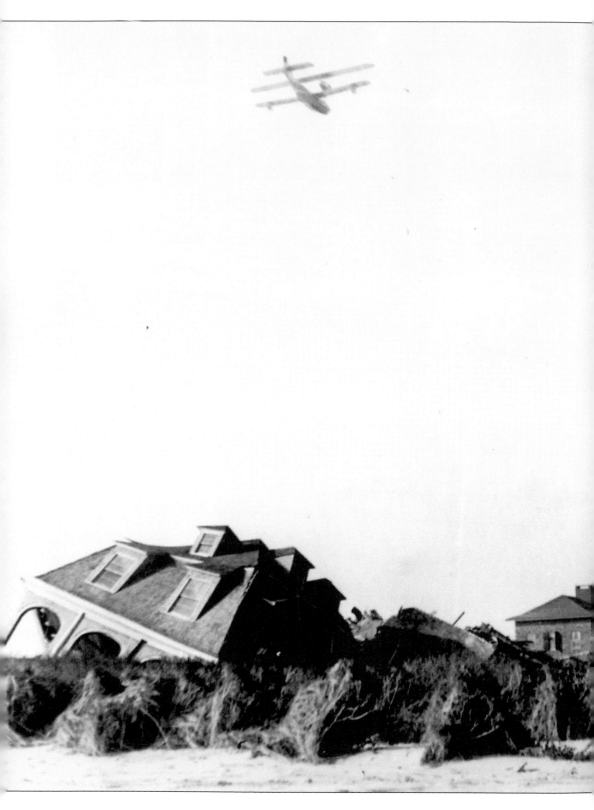

In the first hours after the storm, airplanes were almost the only transportation into the area, so extensive was the damage to bridges, roads, and rail beds. The constant drone of the planes overhead was no doubt a reassuring sign that the area's isolation was not complete, but it also fueled the distressing impression of living in a war zone. And, indeed, the day after the hurricane, Lt. Theodore Harris of the Coast Guard flew the length of Long Island for eight hours trying to spot bodies and report their location. Approaching Westhampton, he said that the land had the appearance of a child's room on New Year's Day with all his toy houses and automobiles broken and warped. (Courtesy Southampton Historical Museum.)

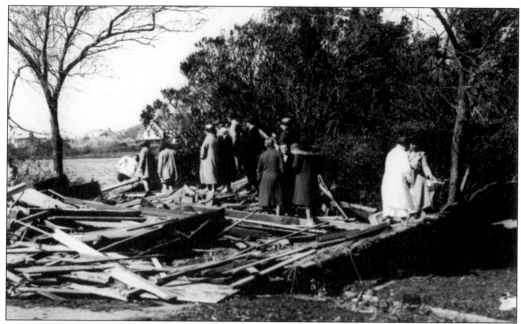

By 5:30 p.m., wrote Ernest S. Clowes in his account, the hurricane was over. Winds were still strong but the clouds were thinning and breaking and the rain was only a fitful drizzle, which lasted until about 7:00 p.m. "People began appearing on the streets and towards six o'clock groups of schoolchildren with linked arms and bright, eager faces were seen battling their way home against the wind." Above, ladies dressed for the drizzle pick their way through the wreckage piled up around Lake Agawam in Southampton. Below, several members of the group survey the cut between Lake Agawam and the ocean where the water came over the dunes, flooded the lake and reached Monument Square at the end of Jobs Lane. When daylight finally faded, wrote Clowes, it signaled the beginning of the darkest night the East End had known since early days, brightened only occasionally by the glare of headlights from one of the few cars that dared to venture out into the village, where fallen trees lay across almost every road. (Courtesy Southampton Historical Museum, Barbara Lord.)

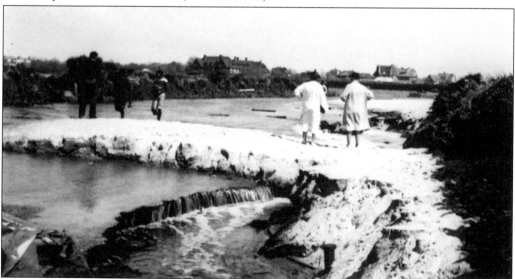

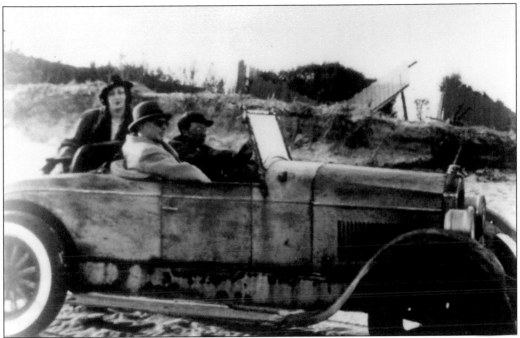

The media, which had totally missed the significance of the coming storm, erred on the side of sensationalism after the fact. Westhampton was declared to have been wiped off the map and everyone who had gathered at the Greene house in Westhampton Beach that morning was said to have perished, although in time all were rescued. The grim news did not deter sightseers, however. Rubberneckers, like the members of this gay party, were on the road surveying the damage as soon as the road cleanup allowed. (Courtesy Southampton Historical Museum.)

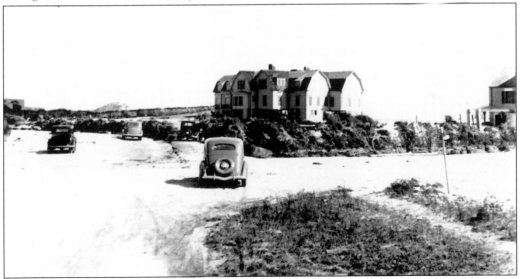

Along the coast, the hurricane washed at least 100 automobiles inland. Afterward it seemed as if every car that was not disabled was in use, transporting the concerned and the curious to the sites most dramatically affected, particularly those, like this one in Southampton, where the dunes had been flattened, allowing the ocean water to rush through. (Courtesy Southampton Historical Museum.)

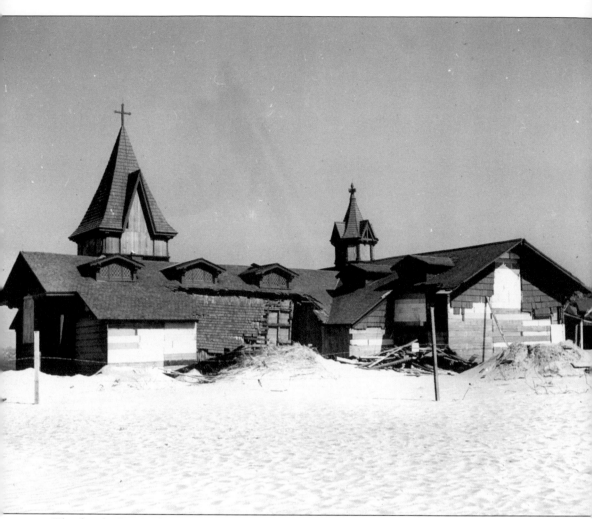

The lovely St. Andrew's Dune Church, which sat on the Southampton dunes between the Atlantic and Lake Agawam, could hardly have been more vulnerable. Early reports were that it had been demolished except, ironically, for its east wall, on which was inscribed the biblical quotation: "Thou rulest the raging of the sea. Thou stillest the waves thereof when they arise." Initial pessimism soon gave way to determination, however. Here some preliminary boards and props have been put in place. Later the shards of its shattered stained-glass windows, some by Louis Comfort Tiffany, were painstakingly gathered from the sand and reassembled. Inexplicably, the memorial window honoring Henry E. Coe was later discovered intact, frame and all, under a hedge a quarter of a mile away. Eventually, through the devoted efforts of its parishioners, the church was fully restored, although subsequent storms have made it necessary to bring it closer to the road and it remains at risk in its lovely but vulnerable setting. (Courtesy George Haddad, Ron Ziel collection.)

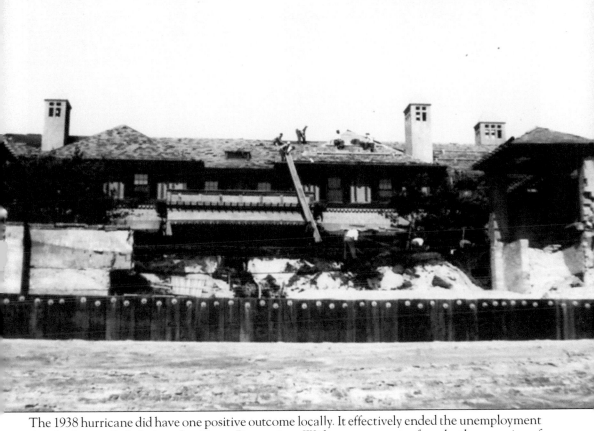

The 1938 hurricane did have one positive outcome locally. It effectively ended the unemployment that had prevailed during the Great Depression. With so many out of work, the promise of employment at the standard wage of $2 a day brought thousands of people flocking to Long Island in search of clean-up work and repair. Hundreds of men were brought into the area by Bell Systems just to repair downed phone lines tangled among the branches of felled trees. Those trees had to be removed from roadways and disposed of, while damaged homes like Josiah Copley Thaw's Windbreak on the beach in Southampton, above, needed extensive repairs. Certainly wealthy homeowners, like Thaw, who were lucky enough to find their beachfront homes still standing after the storm, were ready and able to pay armies of workers to do the job. While the Thaws did, indeed, get their summer palace back in shape for the 1939 season, it did not have the staying power its massive scale and imposing materials seemed to have promised when it was built in 1911. It has long since disappeared from its dune. (Coutresy Southampton Historical Museum, Sheila Guidera.)

As Cherie Burns observes in her book, *The Great Hurricane: 1938*, dawn broke on the day after the hurricane "as pristine and splendidly as ever . . . the air seemed to glisten and the sky was blue and cloudless, with barely a ripple of wind." Had the hurricane been no more than a nightmare, the lovely weather might have suggested a day at the beach. Instead Southampton residents woke to see their streets littered with tree limbs and wires, planks, the occasional piano, or kitchen sink. (Courtesy Southampton Historical Museum, Sheila Guidera.)

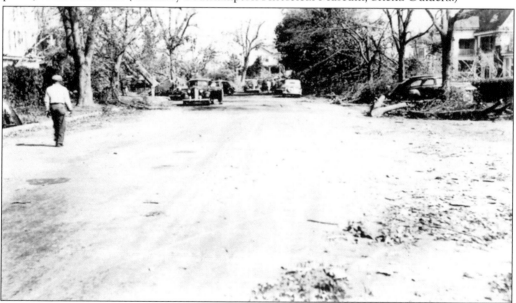

It took weeks for the landscape to be put back in order. Work started immediately but when rain and wind returned on Friday morning, progress suffered a setback. Highways and streets were open by Sunday but sidewalks had to wait. Brush and tree limbs were taken initially to the dump but not burned in the hope that much of it could be used to fill gaps made by the sea through the dunes. Here the view is of Post Crossing, looking east, after a partial cleanup. (Courtesy Southampton Historical Museum.)

A two-man saw eased the burden a bit and made a tedious chore a little less boring for homeowners as they set about cleaning up their houses and yards. For the unemployed, however, any work was welcome and work there was—cleaning up, making repairs, and hauling debris. While in the mill towns of New England, where rivers that had powered factories rose and destroyed them, the hurricane deepened the Depression, many on Long Island saw it as the beginning of the end of economic decline. (Courtesy Southampton Historical Museum, Sheila Guidera)

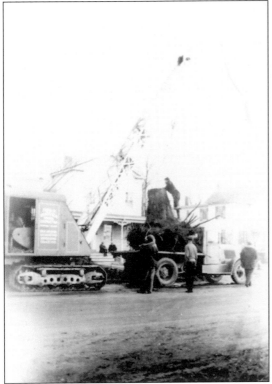

Some jobs required more than a strong back and a handsaw. To remove this giant stump, general contractor Fred Duryea needed something considerably more powerful. The person who snapped this shot at 244 North Main Street in Southampton noted that "H. A. J. and Fred Duryea" are the men on the porch overseeing the operation. (Courtesy Southampton Historical Museum.)

The ruined landscape may have been heartbreaking to their parents, who probably also worried about the risks their offspring ran in roaming the debris-filled streets, children, however, were understandably thrilled by the possibilities for adventure in this strange new world. These three, straddling a tree trunk–turned steed in Southampton, are making the most of the temporary chaos. (Courtesy Southampton Historical Museum, Sheila Guidera.)

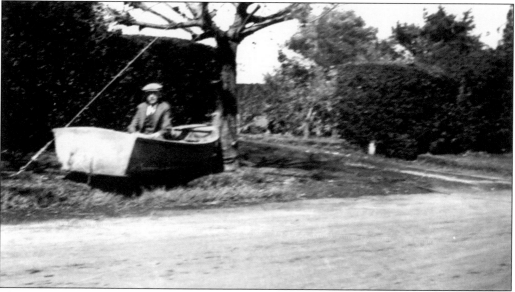

The bizarre distribution of furnishings and artifacts—boats deposited far from the shore, automobiles half buried in beach sand—created some interesting photo ops, few stranger than this shot of a man becalmed in his boat, sailing motionless over the grass somewhere in Southampton. The boat remains nameless, its occupant unidentified. (Courtesy Southampton Historical Museum, Barbara Lord.)

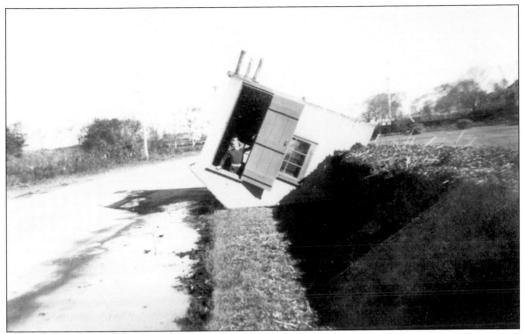

The Phineus Holt playhouse is a fun house fantasy standing on its head after being scooped up by the wind and dropped into the privet. Unlike the full-sized version, this miniature could be easily righted and put back from whence it had been so unceremoniously removed. (Courtesy Bridge Hampton Historical Society.)

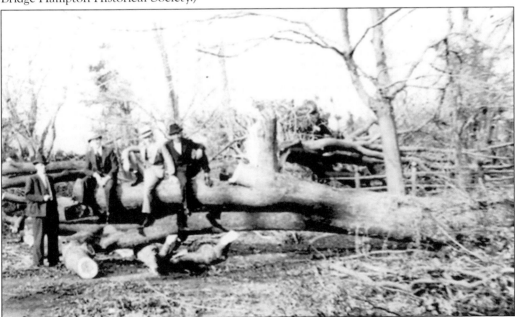

A lot of lifting and sawing has cleared the road here but these well-dressed men posing jauntily on a giant tree trunk were almost certainly not the ones who did the work. The shot is of Ocean Road, then known as Ocean Avenue, looking north toward the Berwind property. The largest stumps would await the arrival of powerful cranes before they could be carried away. (Courtesy Bridge Hampton Historical Society.)

Michael Tureski and his son survey the scene from atop a downed tower that stood near where a helipad was later located at the west end of Dune Road in Southampton. Before the 1938 hurricane, which created the Shinnecock Inlet, the tower was just down the beach from the Shinnecock Lighthouse, where the present Coast Guard station stands now. Such towers toppled like match sticks, while the fragile telephone system was blasted away, leaving residents no way to reassure family and friends, frantic for news. Worse still, warnings that might have saved lives in places about to be visited by the hurricane's fury could not be communicated. As the storm's eye advanced on the coastlines of Connecticut and Rhode Island, no one there knew that it had devastated eastern Long Island two hours earlier. People in Providence went about their business, unaware until it was too late. The storm of unprecedented ferocity arrived, and shoppers drowned in downtown Providence. As it moved inland, the storm lost strength, but before it petered out the next day over Canada, it had left some 700 dead and incalculable destruction. (Courtesy Southampton Historical Museum.)

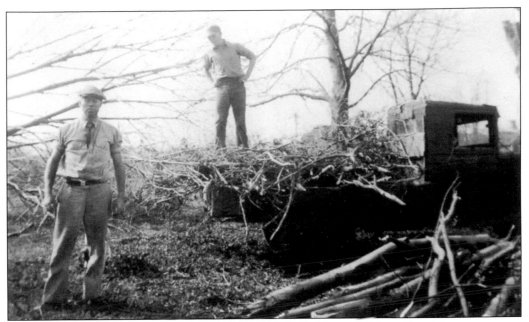

Clean-up on the Sherrill family's dairy farm on North Main Street in East Hampton was a family affair. The roof had been ripped off a barn and shingles from other outbuildings had been sent flying. The windmill that pumped water was damaged and the grounds were a tangle of limbs and trees. Here Edwin Sherrill Sr. and his son survey the work still to be done. (Courtesy Sherrill Foster.)

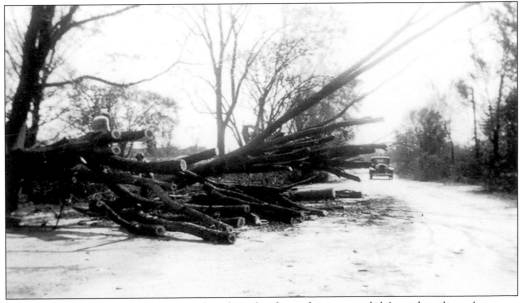

Workers have managed to remove the obstacles from this automobile's path, piling the sawn tree trunks and branches alongside the road to be cleared by heavier equipment. In East Hampton, everyone, including Mayor Judson L. Banister, seems to have pitched in. The mayor was commended for giving his personal attention to the cleaning up of trees and wreckage, a job that was reportedly done with optimum efficiency, thanks to "the perfect functioning of all village departments." (Courtesy Sherrill Foster.)

It would take weeks for the Sherrill family to get the barns and sheds of their 30-cow dairy farm back in shape. Throughout the area, farmers lost barns, garages, and other outbuildings. Potato farmers near the ocean found many acres washed out or buried deep beneath sand from the beach. At the Hendrickson farm in Bridgehampton, 23 buildings that had housed 4,000 chickens were all wrecked. Chickens, blown against a five-foot fence, were drowned in the rain. (Courtesy Sherrill Foster.)

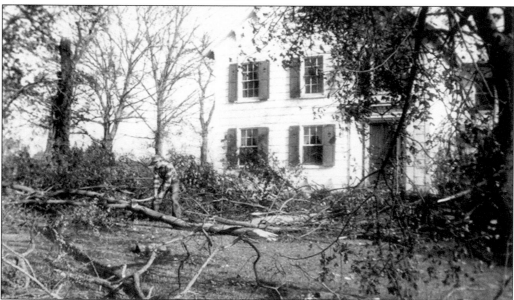

The Sherrill farmhouse appears to have come through the storm without serious damage. While East Hampton was not as hard hit along the coast as areas to the west, its devastating tree loss also took a toll on the homes and stores they hit on their way down. On Main Street, Gertrude Rackett's summer cottage was unroofed by the storm and also had its front wall stripped off, exposing it to passersby as though it were a dollhouse. She miraculously escaped injury and only one East Hampton man, Dominick Grace, died of injuries ashore. (Courtesy Sherrill Foster.)

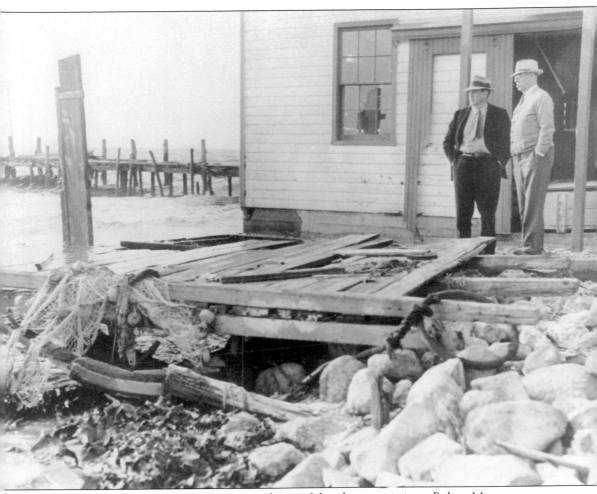

East Hampton supervisor Perry B. Duryea and powerful parks commissioner Robert Moses survey hurricane damage from the front of the Duryea icehouse. It took Moses a couple of days to reach Montauk, which became an island when the ocean swept over Napeague Beach. The washout at Napeague forced a trainload of stricken residents whose homes in the fishing village had been destroyed to return to Montauk, where the Montauk Manor was opened to accommodate them. For several terrible hours Montauk parents whose children were East Hampton High School students, were without news of each other, while rumors of total destruction and loss of life in the fishing village were rampant. At the first opportunity, Duryea sent the following urgent appeal to the American Red Cross and federal relief agencies: "Montauk fishing village practically destroyed. Number of boats lost. Residences destroyed. Several lives lost and missing. No water, light or phone connections. Fishing industry wiped out. Immediate aid necessary." The calamity of 1938, as it turned out, was a step toward modernization; the antiquated icehouse was replaced by a modern refrigeration plant of sufficient size to serve all Montauk's wholesale fish interests. (Courtesy Montauk Library.)

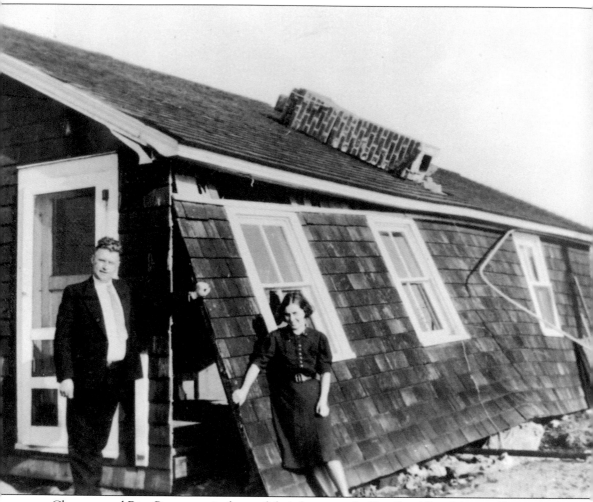

Clarence and Rita Paon pose in front of their home in the Fort Pond Bay fishing village, which has gone down in local lore as "the cake house." As the story goes, Rita and her sisters, Alice and Violet, had gathered together to share a birthday cake. When the winds began to howl and the water menaced, the sisters—who, interestingly, had married three brothers from the Paon family—evacuated to Duryea's icehouse, leaving the cake on the mantel. During the hours that followed, the Montauk landscape was completely transformed. At Duryea's dock the neatly stowed boats and stacked lobster traps were shattered and scattered. The icehouse suffered significant damage, and almost every house in the village was destroyed. And yet, when Clarence and Rita Paon returned to their battered, off-kilter home, there was the cake, unmoved from the mantel, just waiting to be cut. Such freakish incidents provided some much-needed comic relief in the midst of tragedy. The cook at Juan Trippe's dune house in East Hampton found bluefish in her kitchen the next day, and at a neighboring house, turtles were making themselves at home in the rich mud that covered the floors. (Courtesy Montauk Library.)

*Four*

# THE NEXT ONE

The National Oceanic and Atmospheric Administration has collected data indicating that a category 3 hurricane can be expected to hit Long Island every 68 years. Yet in the 68 years from 1938, when the devastating category 3 storm hit Long Island, and in 2006, when that theoretical grace period ended, the pace of beachfront construction only increased, evidence of a certain complacency that even the catastrophic Katrina, which struck the Gulf Coast in 2005, did little to banish.

Today with weather satellites, radar, and other forecasting improvements, any killer hurricane heading toward the Hamptons will be preceded by far more warning than communities received in 1938. There will be ample time to evacuate people.

But where will they go and how will they get there, and what if conditions conspire to make the next big blow even worse? Weather expert Richard Hendrickson has speculated that, in a sense, the unprecedented speed of the 1938 hurricane (at 60 miles per hour, the fastest on record) may actually have prevented the catastrophic flooding that would likely have occurred if the storm had lingered longer over Long Island. Had it been slower, Hendrickson reckoned that it might well have flooded the South Fork and washed away half of both eastern forks, then gone on to flood the Long Island Sound and raise water levels all the way to the city.

One thing is certain: in the Hamptons, a far more populous place than in 1938, the potential for a devastating hurricane will always be present.

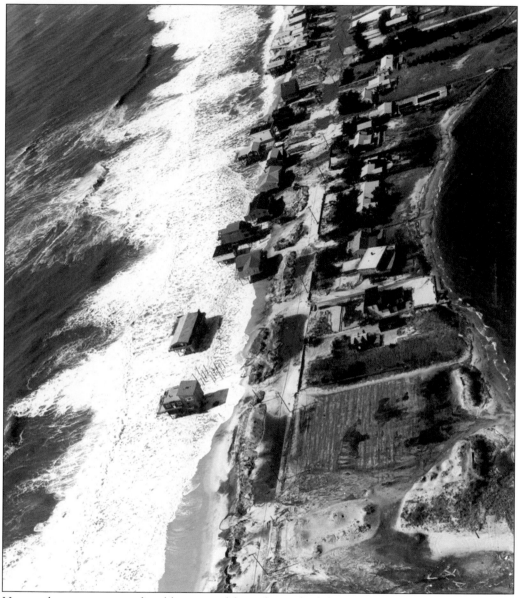

Houses that once sat comfortably removed from the sea had the waves lapping at their doorsteps during this storm. A hurricane with the force of 1938's big blow would likely obliterate all of them. (Courtesy Irl Flanagan, Southampton Aeroservice.)